IMAGES
of America

HONESDALE

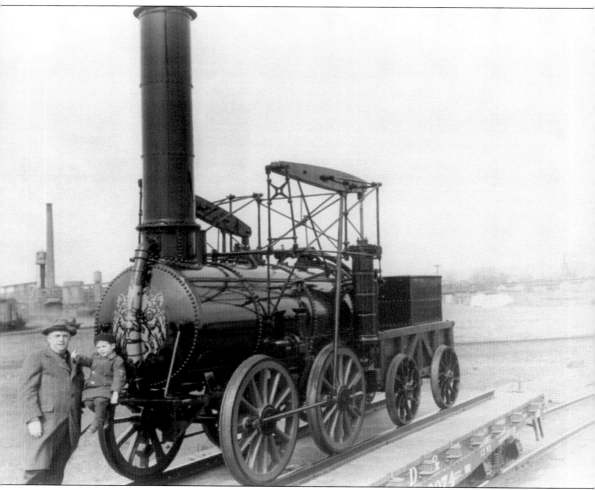

George S. Edmonds (seen in this c. 1933 photograph with his grandson Roland Bates Jr.) was the superintendent of motive power for the Delaware & Hudson Railway at the time of the construction of this replica of the *Stourbridge Lion* steam locomotive. The *Stourbridge Lion* was the first steam locomotive to operate in the United States. This locomotive made its first trip in Honesdale, traveling on a rail from a location behind the present-day post office to Seelyville. When the locomotive reached Seelyville, it could not fit under a bridge because the smokestack was too tall. The lion painted on the front was not commissioned; one of the workers who assembled the train in England just decided to do it. The lion's face was originally painted red. (Courtesy of Wayne County Historical Society.)

ON THE COVER: After the Lackawaxen River overflowed its banks on February 28, 1902, a flood left water and chunks of ice on the streets of Honesdale. This group of locals worked together to clean up the mess. (Courtesy of Wayne County Historical Society.)

IMAGES
of America

HONESDALE

Kim Erickson

ARCADIA
PUBLISHING

Published by Arcadia Publishing
Charleston, South Carolina

Printed in the United States of America

Library of Congress Control Number: 2014954870

For all general information, please contact Arcadia Publishing:
Telephone 843-853-2070
Fax 843-853-0044
E-mail sales@arcadiapublishing.com
For customer service and orders:
Toll-Free 1-888-313-2665

Visit us on the Internet at www.arcadiapublishing.com

I would like to dedicate this book to "my two buddies," Fred Murray and Ed Guinther. Because these two men shared with me their stories of growing up in Honesdale, I was inspired to learn more about our area's local history. They both offered a wealth of knowledge about our town and told some great stories about their younger years. Thank you for sharing with me, so I can share with future generations. Any of the three of us would tell you that history is like an addiction—you find something out and then need to learn about something else.

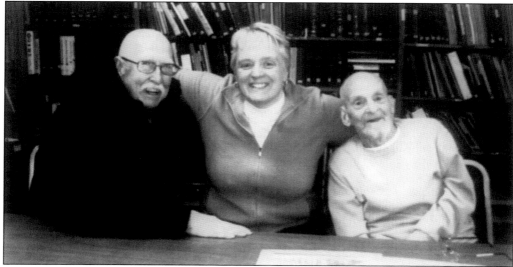

Pictured with author Kim Erickson (center) are Fred Murray (left) and Ed Guinther. (Author.)

CONTENTS

ACKNOWLEDGMENTS

Writing this book was a huge undertaking. I had no idea what I was getting into, but now I can add this to the list of many things I have done in my life thanks to many people. Who knew, when I was younger, that I would be able to say I am an author?

Thank you, to my mother, Peg Pearsall, for always supporting me, with all my crazy ideas, and always encouraging me when I think I might not be able to complete something. Thank you, to many people in the community who sometimes think I am crazy but who always support me because they know I will get the task done and know that I am very community-minded. Without these community members checking my facts and grammar and sharing their stories, this book would not have been possible. Thank you, to Ed Guinther, Fred Murray, and the staff of the Wayne County Historical Society—Kay Stephenson, Jane Brooks and Bart Brooks, Carol Dunn, Jeff Hiller, Tom Kennedy, and Sally Talaga. With the help of these people, I was able to write this book and help my community.

The royalties from this book are being donated to the Wayne County Historical Society so that, for generations to come, our local history will be available for others. Unless otherwise noted, all images appear courtesy of the Wayne County Historical Society.

INTRODUCTION

Honesdale is the home of hidden history. The town is located in the northeast corner of Pennsylvania, which was originally part of Connecticut. This book presents many interesting facts that may make residents want to look deeper into the area's history or prompt a traveler to visit and see some of these things firsthand.

Wayne County was created on March 21, 1798, from Northampton County. In the early 1800s, Maurice and William Wurts bought land in the Lackawanna Valley for 50¢ to $3 per acre and started digging coal. After many unsuccessful attempts to bring the coal to New York City, the Delaware & Hudson Canal Company was started in 1825 by a group of businessmen. The mayor of New York City, Philip Hone, was elected as president of the company. The canal is 108 miles in length, and it took more than 2,000 men and 200 teams of horses and mules to dig the waterway, which was used to transport coal to New York City.

The *Stourbridge Lion*—the first steam locomotive to operate in the United States—ran on August 8, 1829, after being brought to Honesdale from England specifically to work in the coal industry. It was supposed to be built to operate on a four-ton track, but when it arrived, it weighed five tons. It ran from Honesdale to Seelyville, a distance of two or three miles, before it had to stop because the smokestack was too tall to fit under a bridge. The community came to watch this historic event, but many people were nervous and did not know what to expect. The possibility that it could explode was on many minds. Otis Avery, one of the first people to ride on it, reported that it was loud as it was fired up.

Honesdale is not only known for being the home of the first steam locomotive and the Delaware & Hudson Canal, it has also been home to some famous people—Jennie Brownscombe, Christy Mathewson, Dick Smith, Mary Scott Lord Dimmick Harrison, Ruth McGinnis, Homer Greene, and Lyman L. Lemnitzer. These people made our town special through the arts, sports, and the military, and they made a difference in the country.

There have been disasters in Honesdale. The flood of 1942—a huge calamity—cut off downtown from uptown, washed out bridges, destroyed businesses, and killed people. In winter, 52 inches of snow came in one storm. Farmers had to dump milk because there was no way to get it to the creameries; fires claimed lives and destroyed businesses. The Silsby Steamer fire apparatus was not able to fight some of the larger fires, especially when it was 32 degrees below zero and the water froze the equipment.

There are many fun facts about Honesdale. The city has the smallest Jewish temple in the United States, and the only temple with a steeple. At one time, Honesdale had the world's largest stockpile of coal. A 125-room hotel built on Irving Cliff burned to the ground before opening.

As readers look through these photographs, they can discover a number of interesting things. With a little imagination, they can put themselves back in that era while seeing what life was really like at that time.

Have fun reading and learning about Honesdale, Pennsylvania!

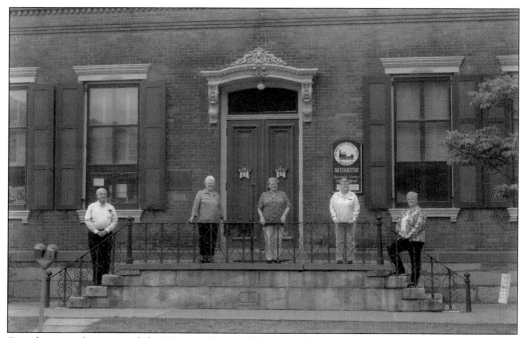

Standing on the steps of the Wayne County Historical Society Main Museum are, from left to right, historical society staff Bart Brooks, Carol Dunn, Kay Stephenson, and Jane Brooks, and the author of this book, Kim Erickson. Society staff assisted in researching the historical data, photographs, and information contained in this book. Established in 1917, the Wayne County Historical Society Main Museum and Research Library is located at 810 Main Street, in Honesdale, Pennsylvania, and has many exhibits on display related to the history of the county. In addition, the historical society preserves and operates Lock 31, Delaware & Hudson Canal Park, 179 Texas Palmyra Highway, Hawley; Bethel One-Room Schoolhouse, Bethel School Road, Berlin Township; Old Stone Jail, Tenth Street at Court House Square, Honesdale; and J.B. Park Farm Museum at the Wayne County Fairgrounds, Route 191, north of Honesdale.

One

GRAVITY RAILROAD AND THE DELAWARE & HUDSON CANAL

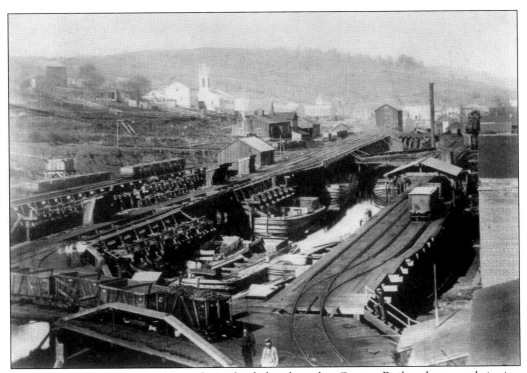

This photograph shows canal boats being loaded with coal as Gravity Railroad cars are bringing coal into Honesdale. The steeple of the original wooden Methodist Episcopal church is visible in the background at center left.

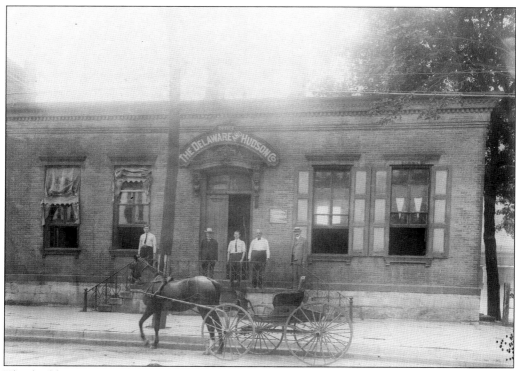

This building at 810 Main Street, which once housed the Delaware & Hudson Canal Company office, is now home to the Wayne County Historical Society's museum. Parked in front of the building is the paymaster's buggy.

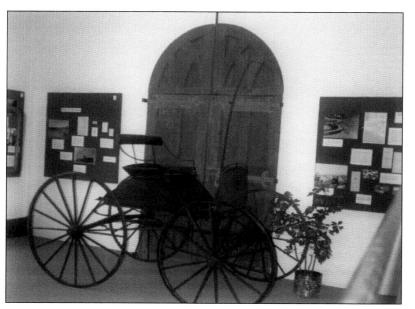

The Delaware & Hudson Canal Company paymaster's buggy was used by Sol Ackerman of Rosendale, New York. It is now on display in the Wayne County Historical Society museum at 810 Main Street.

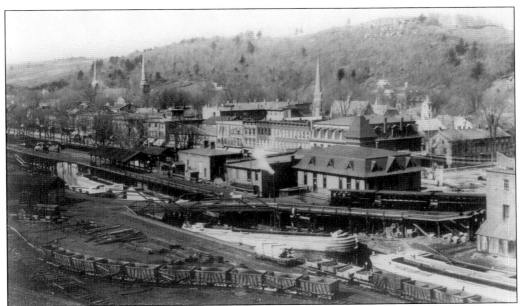

This c. 1875 photograph of central Honesdale shows the coal piling docks. The coal cars in the foreground are lined up next to the Delaware & Hudson Canal waiting for the coal to be unloaded onto the boats. The passenger cars in the background are waiting at the train station.

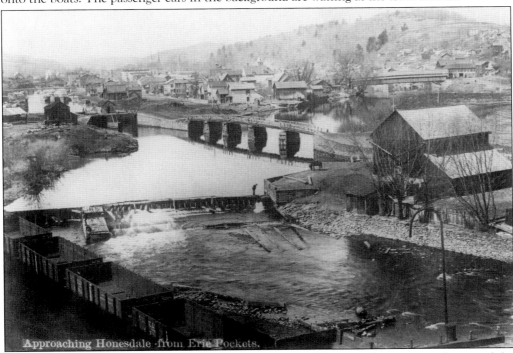

Approaching Honesdale from Erie Pockets.

This picture shows the Lackawaxen River south of Honesdale. Note the empty coal cars and the dam. The towpath and canal, where mules pulled the loaded canal boats, are to the right of the barn. Across the Lackawaxen River, Irving Cliff is in the background. The steeples of several churches, as well as the covered bridge on Fourth Street, are also visible.

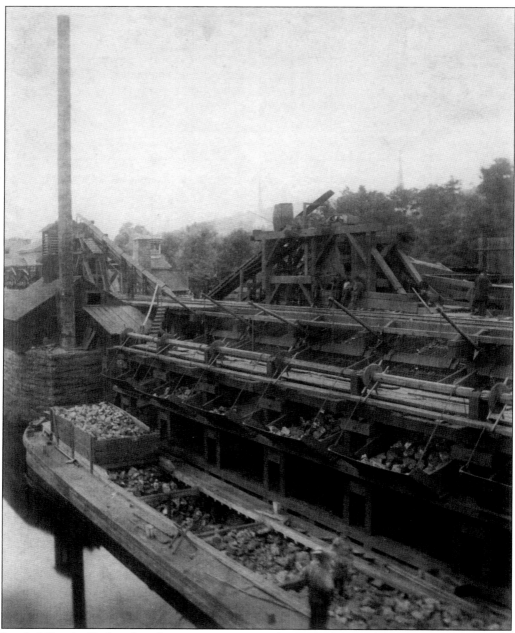

Loaded Gravity Railroad coal cars were transported over the Moosic Mountains to Honesdale. The coal was then loaded onto canal boats through chutes and shipped 108 miles on the Delaware & Hudson Canal to the Hudson River. During the latter part of the 19th century, the fronts of all the stores in town faced the canal, so items from canal boats could be unloaded directly in front of the stores. Today, the backs of the stores face the canal, which has been filled in and built over in many places.

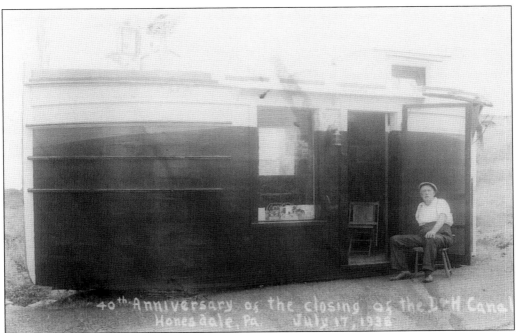

The Kreitner Brothers built this "canal boat" structure for Jim Ennis (pictured), who had lost his arm in a canal accident. It was not as large as a real canal boat, and it never was used to haul coal. This early example of a purpose-built "convenience store" was simply called "the Boat." Pictured here in 1938, it was located on the corner of Ridge and Stone Streets.

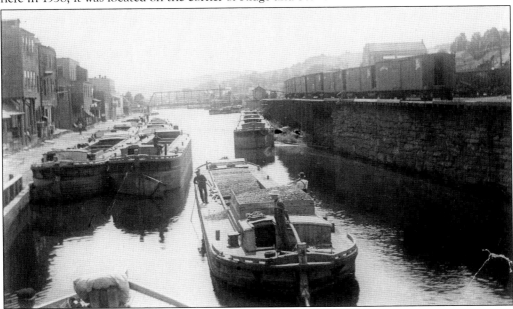

"Canal families" would make about 13 round-trips each year between Honesdale and Rondout, New York. The families lived in a small cabin on the boat, and there was not much room. A boat may have contained three small beds, a small folding table, and a stove. This photograph was taken behind the Delaware & Hudson Canal Company office around 1878.

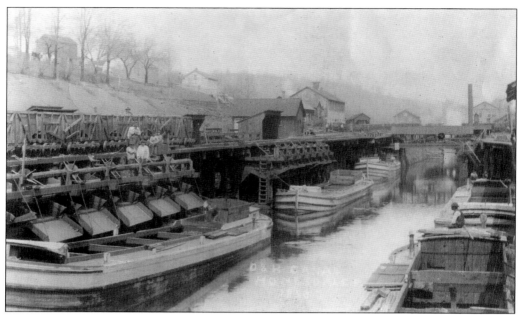

Canal boats sit on the Delaware & Hudson Canal waiting to be loaded with coal. Canal boats could be loaded in approximately 15 minutes by using chutes to transfer the coal, but it took three men three days to unload it at the other end of the canal.

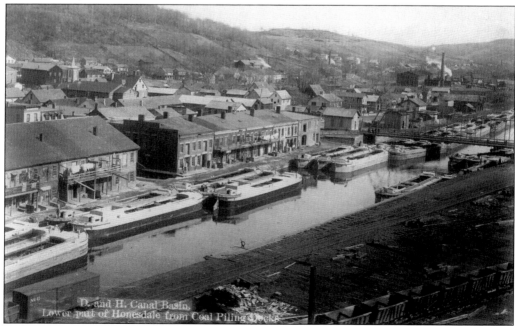

Even before the Delaware & Hudson Canal Company Gravity Railroad, Honesdale had the canal itself to transport coal from the Lackawanna Valley to New York City. At the time this photograph was taken, the front entrances of Honesdale's stores faced the canal, which now faces the rear of the stores on the west side of Main Street. At far right is the bridge over the canal; it now goes to St. John's Catholic Church.

This Main Street bridge once stood at the intersection of Main and Eighth Streets in Honesdale. It crossed the Patmore Basin where the canal boats were stored. The Honesdale National Bank and the Trackside Grill are located at that site today.

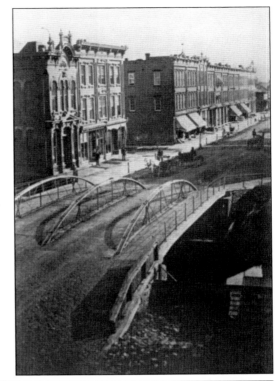

The Delaware & Hudson Canal Company office, built in 1860, is currently home to the Wayne County Historical Society's museum at 810 Main Street. There have been several additions to the building over the decades, but the facade retains its historic appearance.

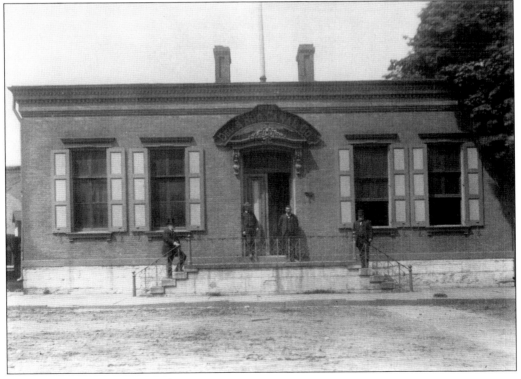

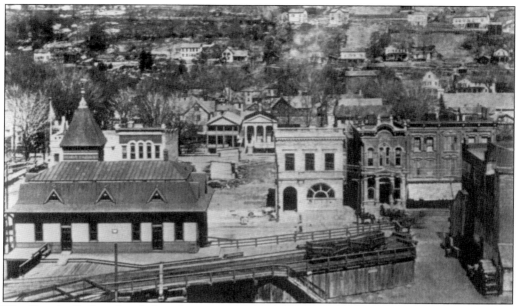

The Gravity Railroad ended in the center of town. The large building in the center is the Erie freight house; the Fred Miller Pavilion and municipal parking lot are now located there. This photograph is from 1875.

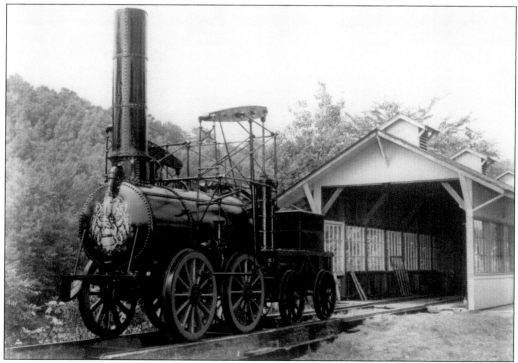

The *Stourbridge Lion* was the first steam locomotive in the United States. It was on display in this building on Park Street until it was moved to the Wayne County Historical Society's museum at 810 Main Street in 1993.

Mishap at the turntable! This turntable, located at the south end of Main Street, was manually operated to direct engines to the correct bay or to turn them around.

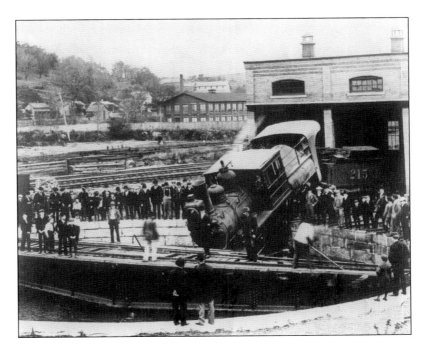

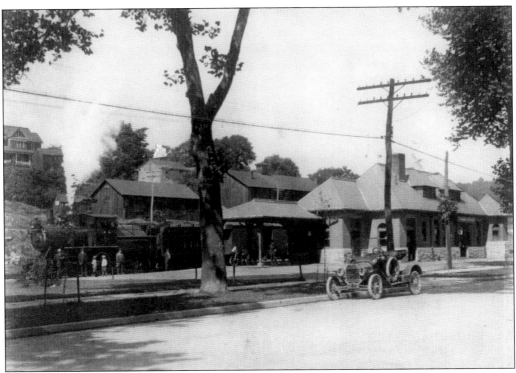

This 1920 postcard shows Union Station, where people could board for New York City or Scranton, Pennsylvania. The station was located on the west side of Main Street at the intersection of Main and Ninth Streets. Today, this is the location of Scarfalloto's Town House Diner.

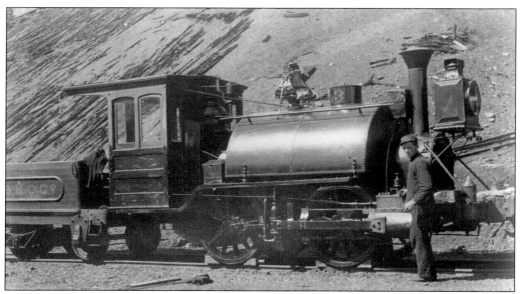

This engine is pulling coal tenders marked with the Delaware & Hudson Coal Company name on the side. The tall pile of coal in the background was only part of what was being shipped to New York on the canal. In the 1870s, there was supposedly a 350,000-ton pile of coal in Honesdale.

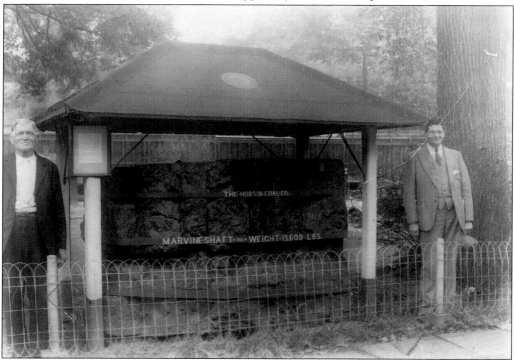

In 1882, this was the largest piece of anthracite coal in existence in America. It was displayed outside the Delaware & Hudson Canal Company office in Honesdale for decades and is currently on display inside the Wayne County Historical Society museum. This piece of coal, which weighs 13,600 pounds, came from the Marvine Mine shaft in North Scranton, Pennsylvania.

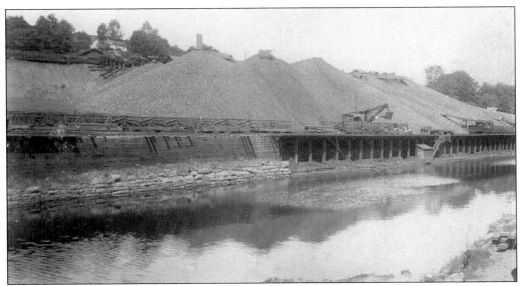

During the time that the canal was active (1828–1898), the world's largest pile of coal sat parallel to Honesdale's Main Street. Steam shovels were used to move the coal and to load it into canal boats. Plane 13 of the Gravity Railroad was located above this pile of coal.

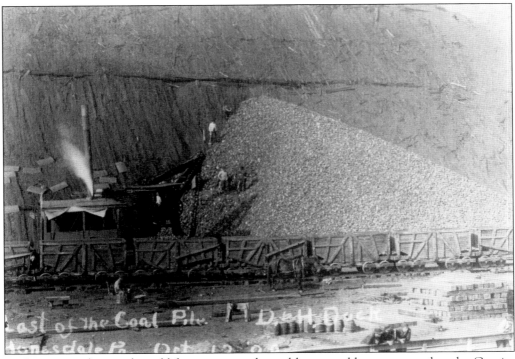

Last of the Coal Pile. D & H Dock
Honesdale Pa. Oct. 1898

In the winter, the canal would freeze over, and canal boats could not operate, but the Gravity Railroad still brought coal over Moosic Mountain and unloaded it in Honesdale, forming a pile of anthracite coal that extended from Fifth Street to Eighth Street. The last canal boat carrying coal left Honesdale on November 5, 1898.

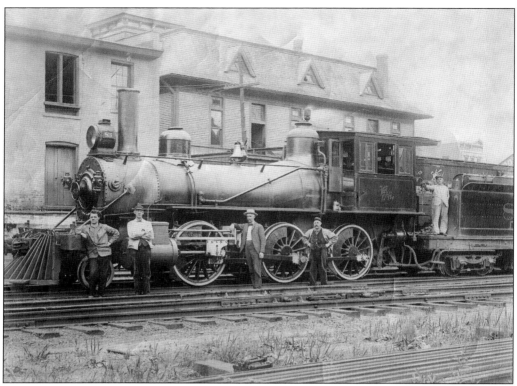

This image shows Engine No. 83 stopped behind Union Station, where children would try to jump on the trains for a ride. Once, on Armistice Day, one of the children did not make it onto the train and ended up losing his legs.

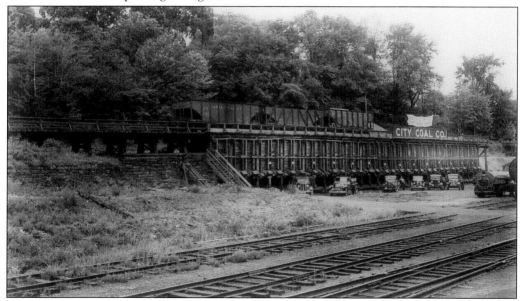

City Coal Company was behind the present-day location of the post office on Main Street. People in horse-drawn wagons or trucks came here to get coal to heat their homes.

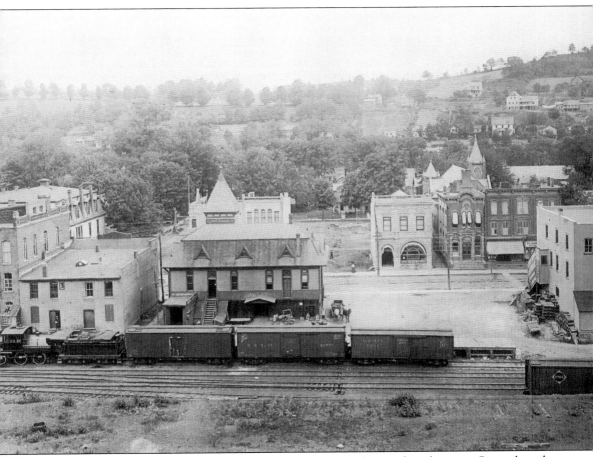

This c. 1908 photograph of Main Street, with a view that looks east from between Seventh and Eighth Streets, shows the former Wayne Independent Building at far left. There was a small pool hall in the shorter building located next to the freight house. The structure with the large arched window, across Main Street, is the Wayne County Savings Bank. The next building to the right is Dr. Flora's dentist's office, then the Army Navy Store. In the foreground, a train is being unloaded into the freight house.

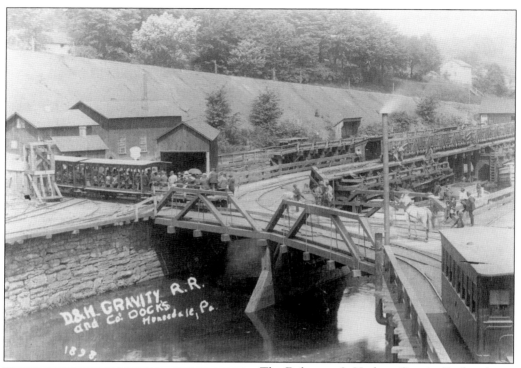

The Delaware & Hudson Gravity Railroad docks are pictured here in 1898. The open railcars could take passengers to Farview Mountain, near Waymart, for picnicking.

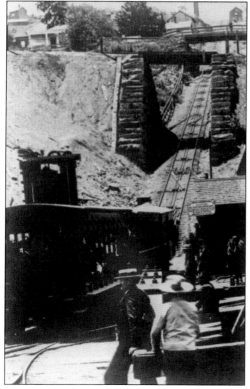

There were two Gravity Railroad planes in Honesdale—Plane 9 and Plane 13. This image shows Plane 13 and people possibly going for a ride to Farview Mountain.

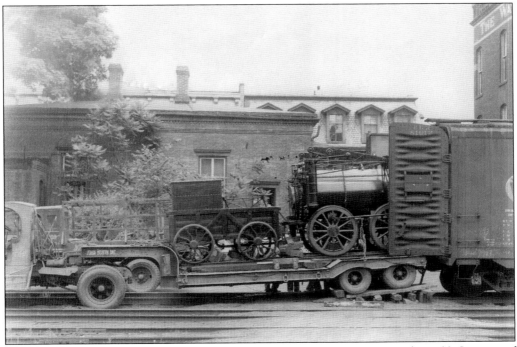

The *Stourbridge Lion* replica arrived in Honesdale after its appearances at the 1933 Century of Progress Exposition in Chicago and the 1939 New York World's Fair. It was transported by train to its home at the Delaware & Hudson Canal Company building on Park Street, where the replica was dedicated on November 11, 1941.

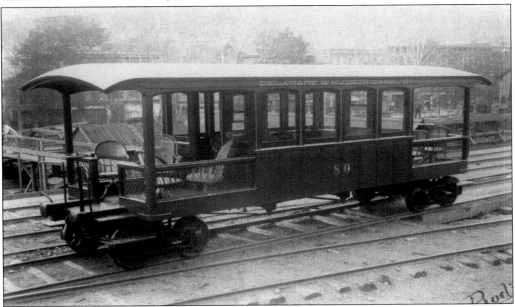

Open-air passenger cars were used to take people to places like Farview Picnic Grounds and Observatory. Some of these cars were plain and may have had just a bench in them. Other cars had plusher accommodations for people such as railroad executives and wealthier folks.

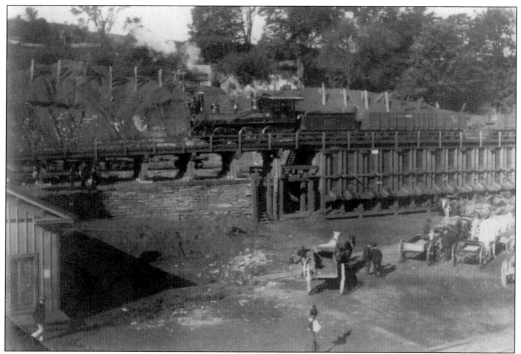

The current location of the Wayne County Historical Society and Honesdale Post Office was once the coal pocket. People would come with horses and wagons to get coal to haul home. Some of the men owned businesses which would deliver coal to families that lived farther out in the country.

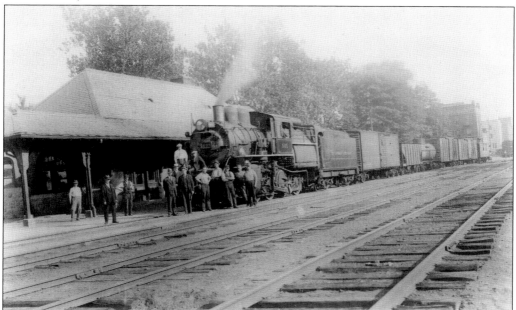

This c. 1898 photograph shows Honesdale's train depot and four sets of rails. A steam locomotive, pulling a short freight train, is stopped in front of the station.

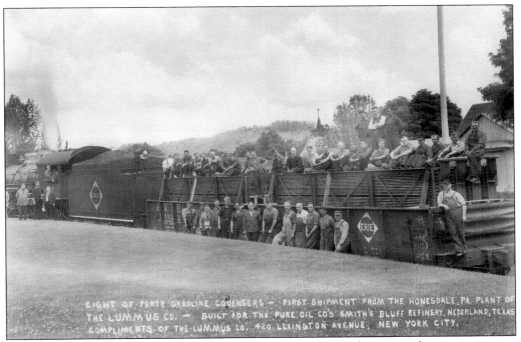

EIGHT OF FORTY GASOLINE CONDENSERS — FIRST SHIPMENT FROM THE HONESDALE, PA. PLANT OF THE LUMMUS CO. — BUILT FOR THE PURE OIL CO'S SMITH'S BLUFF REFINERY, NEDERLAND, TEXAS COMPLIMENTS OF THE LUMMUS CO. 420 LEXINGTON AVENUE, NEW YORK CITY.

The train was a huge asset in transporting items from local manufacturers to bigger cities across the country. This photograph, taken on June 14, 1938, shows the first shipment of gasoline condensers built by the Lummus Company and headed for the oil fields of Texas.

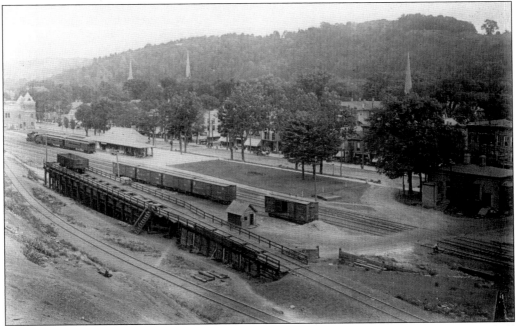

The view of Honesdale in this 1908 image is looking northeast from the coal pockets. City hall is the building at far left, which shows how much the town has changed. Note the passenger cars at Union Station. The grassy area in the center is where the post office is currently located.

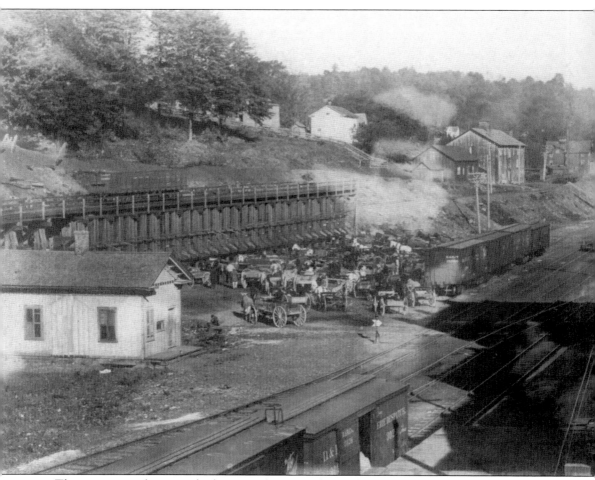

The picture, with a view looking northwest at the coal pockets after the canal was filled in, shows how people would come to the pockets to fill wagons with coal. Freight trains are visible in the foreground.

Two

PEOPLE OF INTEREST

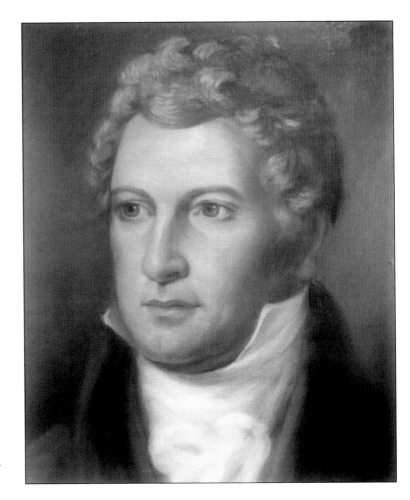

Honesdale was named after Philip Hone (1780–1851), who served as the first president of the Delaware & Hudson Canal Company in 1825 and 1826. He also served as the mayor of New York City (for one term) in 1826–1827. The area was known as Dyberry Forks before it was formally named after Hone.

Horatio Allen was a civil engineer who worked on the Delaware & Hudson Canal. Allen went to England on behalf of D&H, where he ordered four locomotives to be shipped to the United States, and the *Stourbridge Lion* was one of them.

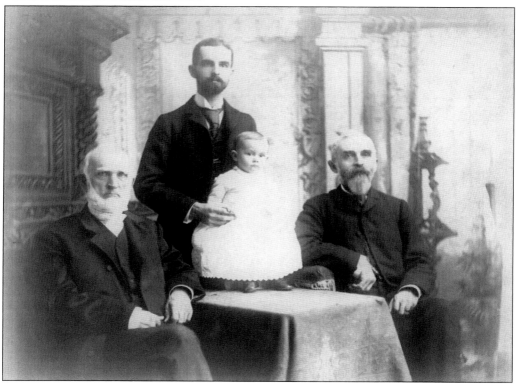

Jason Torrey (1772–1848) was a Wayne County land developer and surveyor. He was occasionally paid in land for his services. Torrey owned the northern part of Honesdale, which was given to him in exchange for work he did for William Schoonover. The Delaware & Hudson Canal Company donated two lots of land to the Episcopal Society, and the Episcopalians asked Torrey to match the donation with two lots facing the public square so they could build a church. Since he was a Presbyterian, Torrey was quick to donate an equal amount to the Presbyterian church. This photograph shows two of Torrey's 11 children—his sons John (left) and Rev. Stephen Torrey (right). The baby and the man holding it are unidentified.

On August 8, 1829, Dr. Otis Avery, a Honesdale dentist and inventor, was one of the brave people who rode on the *Stourbridge Lion* on one of its early runs—after Horatio Allen completed the first trial run.

John Stegner, a Honesdale businessman who founded the J.H. Stegner Grocery and Bakery, also owned a canal boat that would carry coal and freight to Rondout, New York.

William Turner, a boatbuilder on the Delaware & Hudson Canal, repaired damaged canal boats at the Patmore Basin in Honesdale.

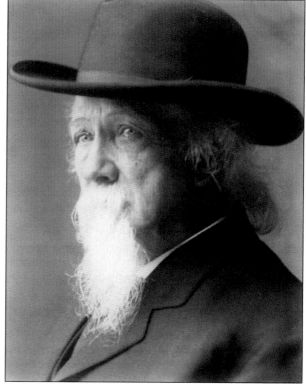

Thomas J. Ham was the editor and publisher of the *Wayne County Herald*, established in 1842. Early Honesdale had other newspapers, including the *Wayne Citizen*, established in 1868 by Wilson and Penniman, editors and publishers; the *Wayne Independent*, established in 1878 by Benjamin F. Haines; and *Das Journal*, a German-language newspaper established in 1875 by Nicholas Keifer.

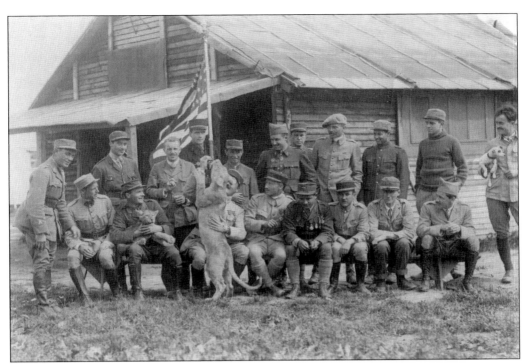

Maj. David McKelvy Peterson (second row, second from right) is pictured with fellow volunteers of his all-American squadron— l'Escadrille Américaine, later l'Escadrille La Fayette—of the French Aviation Service in their World War I uniforms. The men are posing with the company's lion mascots, named Whiskey and Soda. Peterson is buried in the Glen Dyberry Cemetery, but an empty marble tomb was erected in his honor at the La Fayette Escadrille Memorial near Paris. This empty tomb reflects the memorial officials' desire for Peterson to be entombed at the site following his death in a Florida plane crash in 1919; his family preferred he be buried in his hometown.

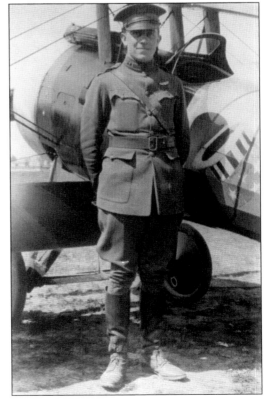

Maj. David McKelvy Peterson was the United States' first "flying ace." He earned the title after shooting down five enemy planes. He was credited with shooting down 23 enemy aircraft, including two in one day. Peterson died in a plane crash in Florida on March 16, 1919, and is buried in Honesdale's Glen Dyberry Cemetery.

This c. 1885 image shows Francis Asa Dimmock dressed in costume for a carnival at the Honesdale skating rink. The skates he is holding clamped onto the bottom of the shoes with a strap that went over the top of the foot, and a special key was required to secure them.

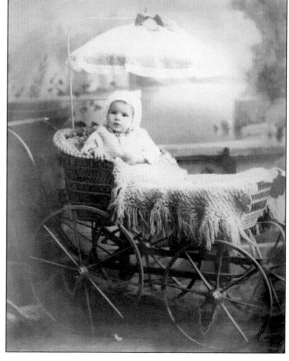

Molly Menner is pictured at the age of one in her wicker carriage with an umbrella. Years ago, an umbrella man would walk through the streets of Honesdale singing a tune to let people know he was in town. If someone needed an umbrella fixed or knives sharpened, they could take them to the umbrella man.

Honesdale native Dick Smith is best known for writing the lyrics to the popular holiday song "Winter Wonderland." His former home is located on Church Street across from Central Park. The snow-covered park reportedly inspired the words to the song.

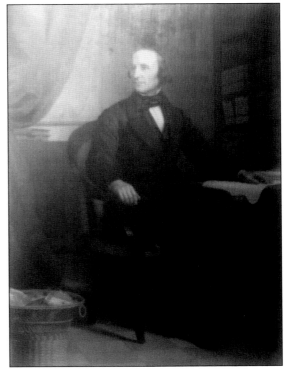

John Wurts, the third president of the Delaware & Hudson Canal Company, held the position from April 13, 1831, until March 15, 1858. The youngest brother of Maurice and William Wurts, John served in the lower house of the Pennsylvania General Assembly as well as in the state senate, where he was a great asset to his brothers in terms of getting bills passed to enhance their business of getting coal shipped to New York by canal.

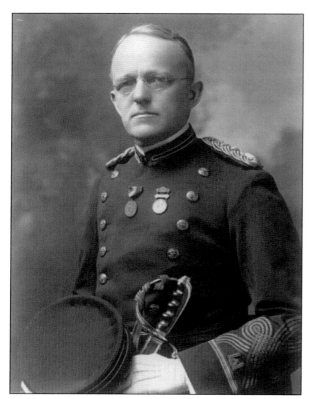

Lt. Gen. Edgar Jadwin (left) served as chief of engineers in the US Army Corps of Engineers from 1926 to 1929. In 1958, the town of Honesdale renamed the Dyberry Dam and Reservoir after him. Gen. George Washington Goethals selected Jadwin as an assistant during the building of the Panama Canal. Edgar's wife, Jean Laubach (below), stands outside of her home at 827 Church Street in Honesdale.

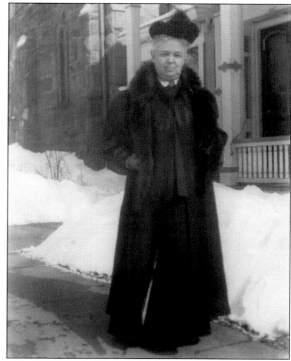

Lucy Ann Lobdell (1829–1912), pictured here in Native American clothing, was known as—according to her autobiography—the "Female Hunter of Delaware and Sullivan Counties, NY." In 1878, she bought a farm in Damascus Township, in Wayne County, and worked as a man at logging camps in Pennsylvania and New York. She did not believe that women should be paid less than men, and she spent time in Honesdale's Old Stone Jail for impersonating a man and calling herself Joseph Israel Lobdell.

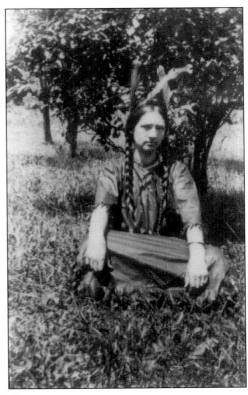

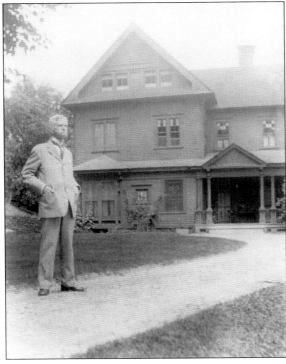

Homer Greene—an attorney, author, and poet—chose to live in Honesdale despite his opportunities to live in a more profitable location. He wrote many books and short stories for both adults and children. Community involvement was very important to Greene; he was president of the Wayne County Bar Association, director of the Honesdale National Bank, president of the Wayne County Historical Society for 17 years, and president and organizer of the Honesdale Rotary.

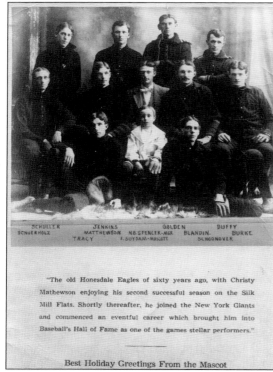

SCHULLER JENKINS GOLDEN DUFFY
SCHUERHOLZ MATTHEWSON N.B.SPENCER-MGR. BLANDIN. BURKE
 TRACY F. SUYDAM - MASCOT SCHOONOVER

"The old Honesdale Eagles of sixty years ago, with Christy Mathewson enjoying his second successful season on the Silk Mill Flats. Shortly thereafter, he joined the New York Giants and commenced an eventful career which brought him into Baseball's Hall of Fame as one of the games stellar performers."

Best Holiday Greetings From the Mascot

Christy Mathewson (second from left in the second row) played for the Honesdale Eagles Baseball Club in 1898 and 1899. After two seasons in Honesdale, he became a successful pitcher for the New York Giants. He is in the National Baseball Hall of Fame, where the statement "Matty was master of them all" appears on his commemorative plaque. Mathewson holds the National League record of 373 victories and is recognized as one the greatest pitchers in the history of baseball.

W.H. Varcoe is shown around 1930 viewing an eclipse in front of St. John's Evangelical Lutheran Church on Seventh Street. Varcoe owned and operated a printing company, the Varcoe Printing House, in Honesdale for many years. Varcoe Printing remained in business from 1878 until being merged with another company in 2010.

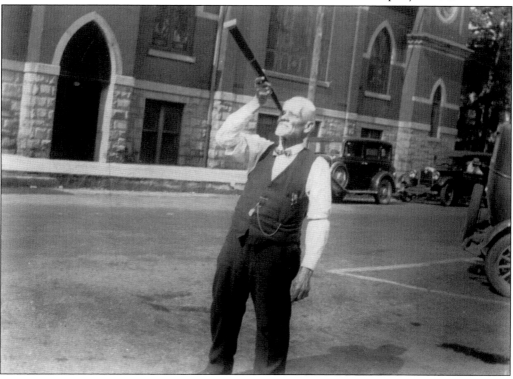

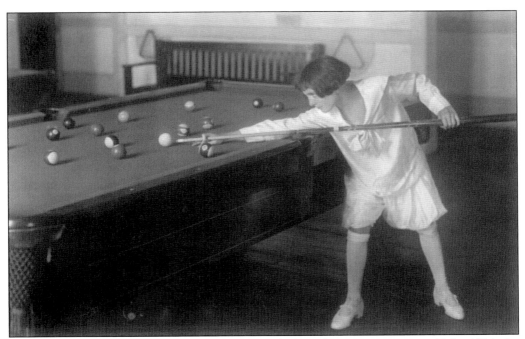

Ruth McGinnis, born in 1911, began playing pool when she was seven years old; by 1934, she was the woman's pocket billiard champion of the world. When she defeated the Olympic track-and-field champion, Babe Didrikson, at pool, McGinnis became a national celebrity. Then, in a special exhibition match, she also defeated Ralph Greenleaf, the men's world champion. In 1950, McGinnis returned to Honesdale, became a teacher, and managed her father's businesses. She was inducted into the Women's Professional Billiard Association Hall of Fame in 1976.

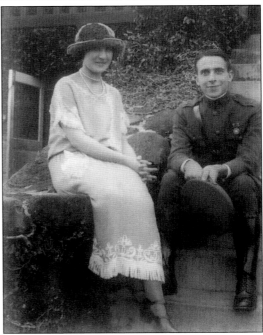

Gen. Lyman L. Lemnitzer and his wife, Katherine "Kay" are pictured during their honeymoon in Hawaii in 1923. General Lemnitzer was in the US Army for 51 years before he retired. He ultimately reached the rank of four-star general. During his career, he held many command posts, including chief of staff of the Army, chairman of the Joint Chiefs of Staff, and supreme allied commander of NATO. The Lemnitzer home still stands on West Street in Honesdale.

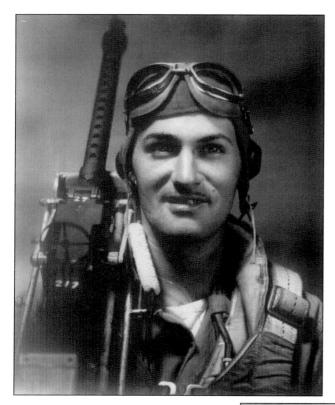

Edgar Pohle, a well-known Honesdale merchant and gunner in the US Army Air Corps during World War II, was shot down behind enemy lines in 1943. With the aid and assistance of Italians, he steadily made his way through German-held territory to security behind the British lines. It was more than six months before his fate was known to his family and the concerned local community.

Art Wall Jr., a professional golfer who lived in Honesdale, was a member of the Honesdale Golf Club; at the age of 15, he won the club championship and later repeated that win four more times. Wall became a professional golfer in 1940 and won the prestigious Masters Golf Tournament in 1959. He was credited for making 45 holes in one in his lifetime.

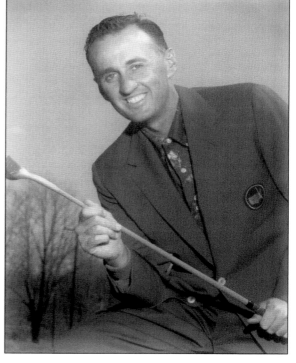

Three

THE WAY IT WAS

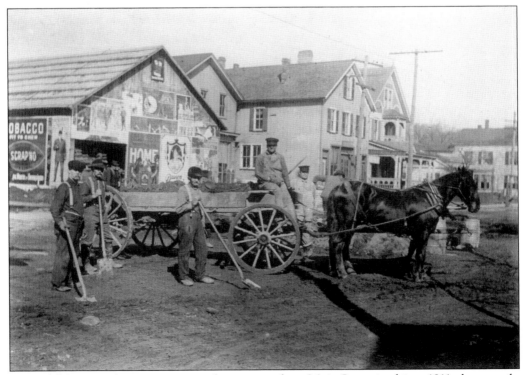

Honesdale's street-cleaning service is shown at work on Main Street in this c. 1911 photograph.

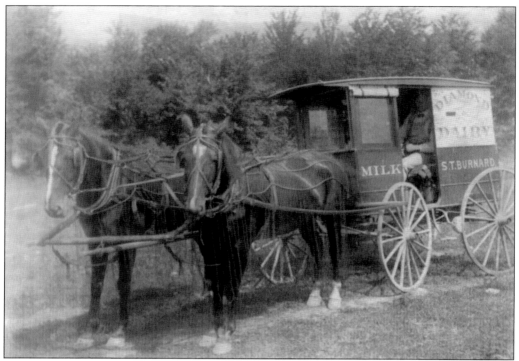

S.T. Burnard owned the Diamond Dairy. Each day, Burnard would deliver milk in his wagon pulled by his sturdy horses. Note the horses' fly nets, which moved as the horses moved and kept the flies away from them.

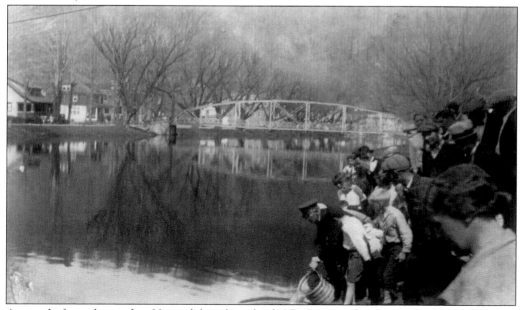

A crowd of people watches Honesdale police chief N.B. Spencer dump trout in the Lackawaxen River's Park Lake in 1932. In the background is the Court Street footbridge, which washed away in the 1942 flood.

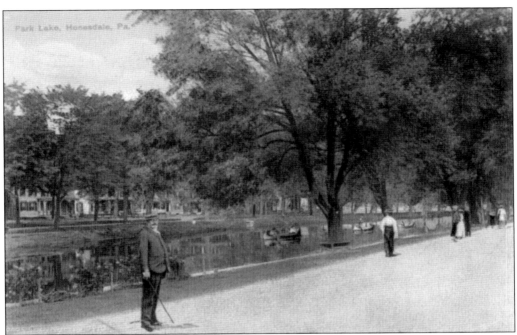

This postcard shows people strolling along Twelfth Street next to Park Lake on the Lackawaxen River. Others are boating on the lake. Across the lake are the lovely homes of Park Street.

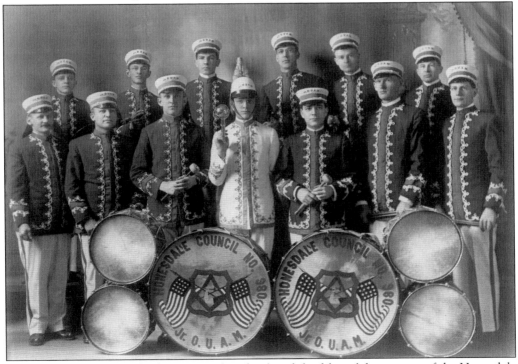

This photograph shows the drum major (in white) and the fife and drum corps of the Honesdale Council No. 980 Junior Order of United American Mechanics.

The Lyric Theater, built in 1907, included 920 seats, an orchestra pit, a dance hall, a banquet hall and spaces for businesses. At lower right is the Frank A. Jenkins Music House. The private home at left belongs to Eugene Cortright. *Godzilla* was playing at this theater when it burned down in 1961. A Turkey Hill Minit Market now sits at this location.

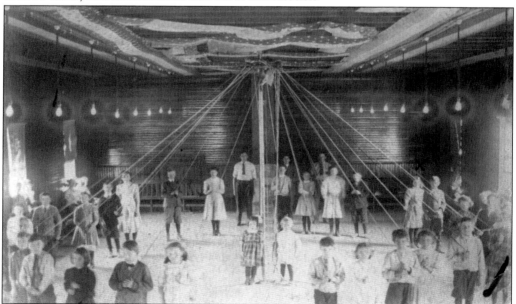

This maypole dance was held at the Alert Fire Hall. Maypole dancing is a form of folk art that originated in Germany, England, and Sweden and usually occurs on May 1 (May Day). The dancers intertwine their ribbons and dance around the pole, then unravel the ribbons by retracing their steps.

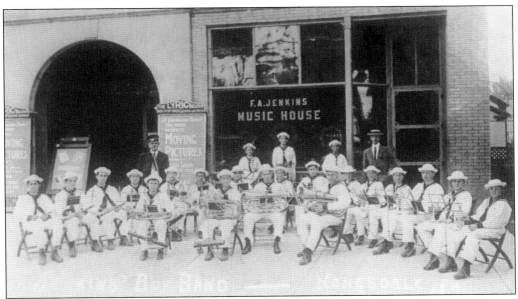

Bob Dorin directed the Honesdale Boys' Band, pictured here in 1916 in front of the Lyric Theater and the Frank A. Jenkins Music House. Jenkins promoted the group, which is misnamed on the photograph. There were many fife and drum corps and brass bands in Honesdale during the 19th and 20th centuries.

Ruth Spangenberg and E.B. Calloway ride in a horse-drawn decorated carriage for a Honesdale parade. The sign indicates they are representing the Honesdale Chamber of Commerce.

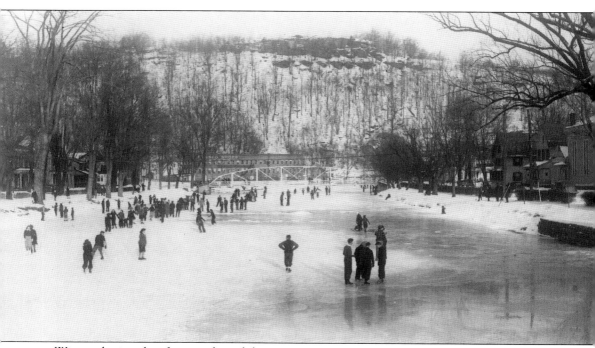

Winter skating, bonfires, and ice fishing were common winter activities at Park Lake on the Lackawaxen River. In this image, Park Street is at left and Twelfth Street at right. In the background, beneath Irving Cliff, are the Court Street walking bridge and the Honesdale Union Stamp and Shoe Company (HUSSCO).

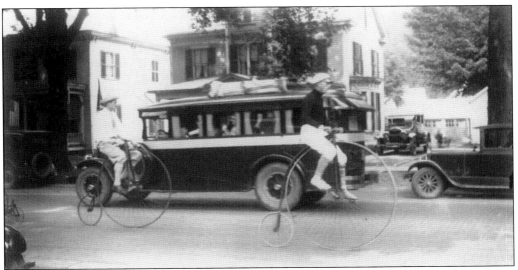

Taxi and bus service were available in Honesdale, and high-wheeler bicycles were also popular. This type of bicycle was also known as the penny-farthing (or ordinary) and became a symbol of the late Victorian era. Its popularity also coincided with the birth of cycling as a sport.

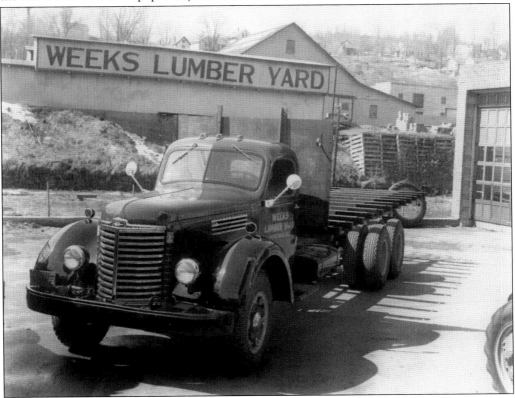

Weeks Lumber Yard was established in 1946 behind the present-day location of Kinsman's on Main Street. This lumberyard was located along the canal bed. Weeks used the 10-wheel truck in this photograph to make many deliveries around the area.

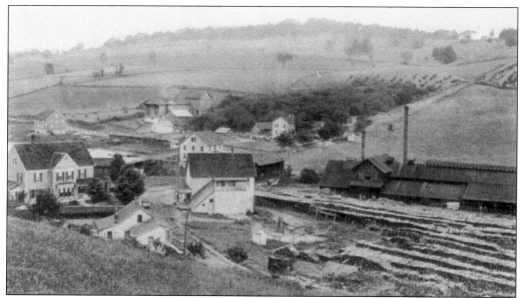

John Riefler and Sons had an extensive lumber business and was also interested in the manufacture of wood alcohol and acetate of lime. The company had two large factories near the junction of the east and west branches of the Dyberry River. In the 1920s, it would deliver lumber, wood alcohol, acetate of lime, and charcoal around town.

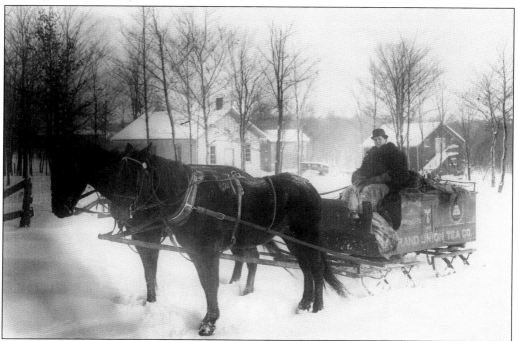

The Grand Union Tea Company, established in Scranton, Pennsylvania, not only had a grocery store, but it also employed door-to-door salesmen and made deliveries in horse-drawn wagons. In Honesdale, during the winter, Grand Union Tea Company would deliver merchandise to customers in this horse-drawn sled.

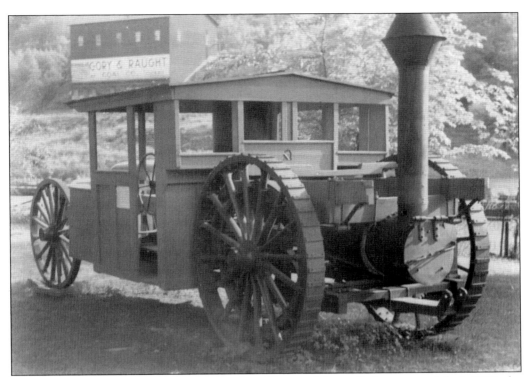

The David Spencer Steam Tractor was built in Pleasant Mount. It first ran on July 4, 1889; the tractor could travel at a speed of four miles per hour and required both a driver and a fireman to operate it. In the background is Gregory & Raught's coal pocket on Commercial Street.

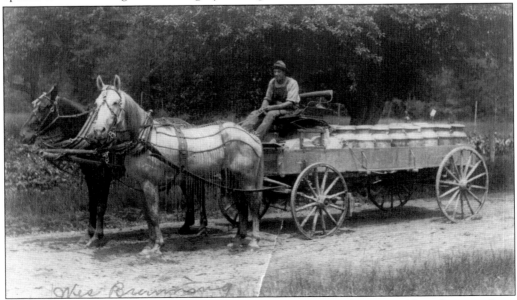

Milk would be delivered from local dairy farms to the creameries by wagon. Note the many large milk cans in the back of this wagon driven by Wes Branning. The horses are sporting fly nets to keep away the bothersome flies.

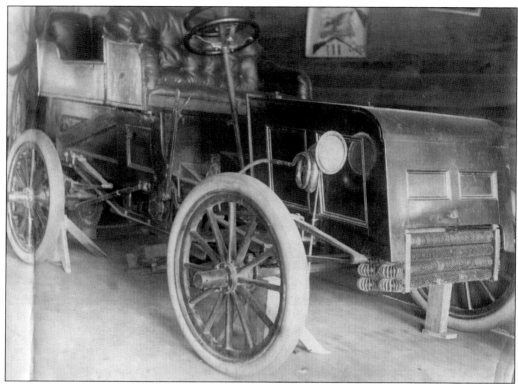

In 1904, Charles E. Gibbs built this, the first car in Honesdale, although part of it was built by the National Elevator Company in Honesdale. This car was only used for one season.

Joe Lee and his nephew were known as the laundrymen because they owned Joe Lee Laundry at 1042 Main Street.

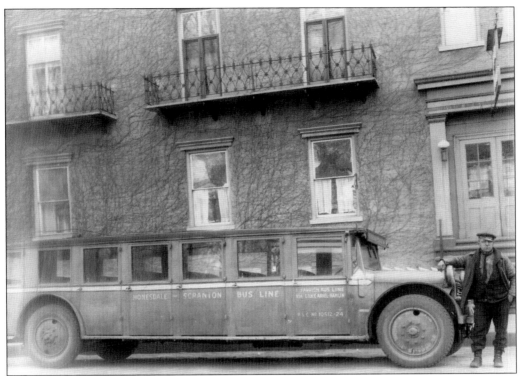

Fred Parrish, owner of Parrish Bus Line, is standing in front of one of his buses at the Allen Hotel in Honesdale. His bus line ran between Honesdale and Scranton and regularly stopped in front of the hotel. Note the five doors along the side of the bus.

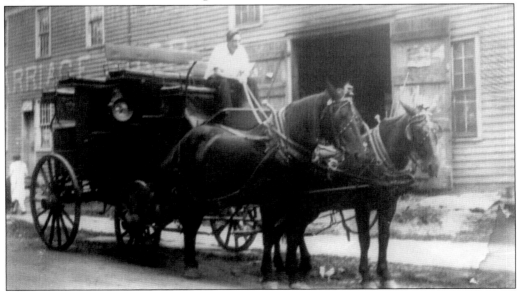

This stagecoach traveled between Honesdale and Milford. In Milford, the seat of Pike County, visitors can see this Hiawatha stagecoach, which has been restored and is used for special occasions, at the Pike County Historical Society at the Columns.

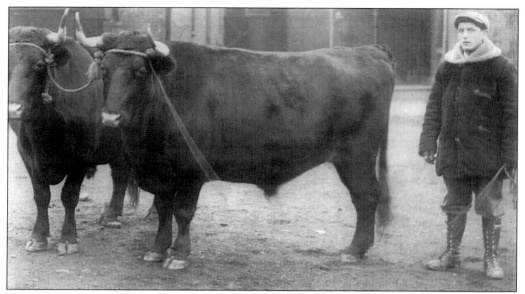

Seventeen-year-old Norman Henderson is standing with his oxteam in front of Dein's Butcher Shop. Teams of oxen were used to deliver bread or milk and to haul other products. At times, it was common to see men herding cattle onto Honesdale's Main Street from farms at Bunnell's Pond or Cherry Ridge on the way to the butcher or the train.

The North Main Street home of Joseph D. West was referred to as the "Mud House" by some locals because the mud and straw placed between the interior and exterior walls became saturated during the 1942 flood and started to bulge after the flood waters receded.

CHURCH STREET, HONESDALE, PA.

The building at left is the Allen Hotel, which was destroyed by fire on November 5, 1978. It stood at the intersection of Ninth and Church Streets. The white building in the center, formerly the Dimmock home, is now known as the Park Hotel.

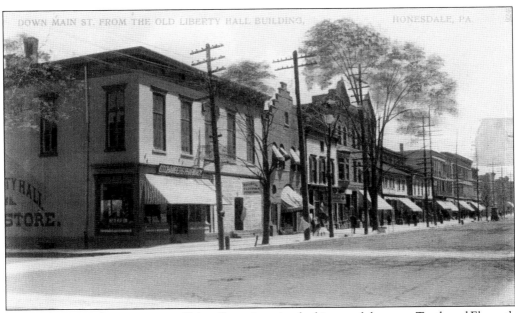

DOWN MAIN ST. FROM THE OLD LIBERTY HALL BUILDING, HONESDALE, PA.

This early picture shows an unpaved Main Street in a view looking south between Tenth and Eleventh Streets. The dirt street is lined with maple trees, most of which are no longer standing.

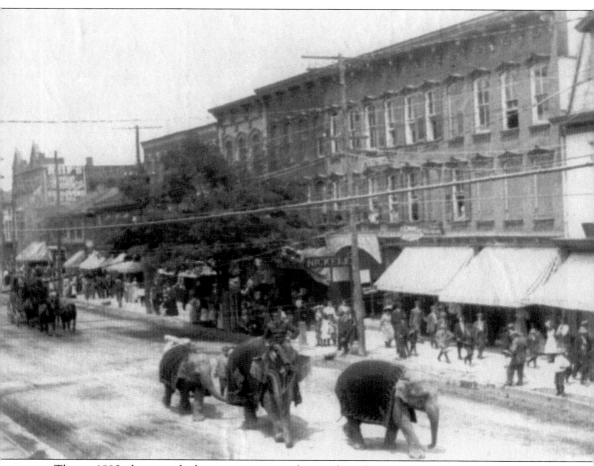

This c. 1890 photograph shows a circus parade traveling down Main Street. The elephants are passing in front of the Globe Store, where many people gathered to watch this event. The parade was a great promotional event for the circus and allowed those who could not afford to go to the circus to see the animals.

The Union Railroad depot is the building in the background at left. Main Street is at right. The large grassy area is now home to the post office.

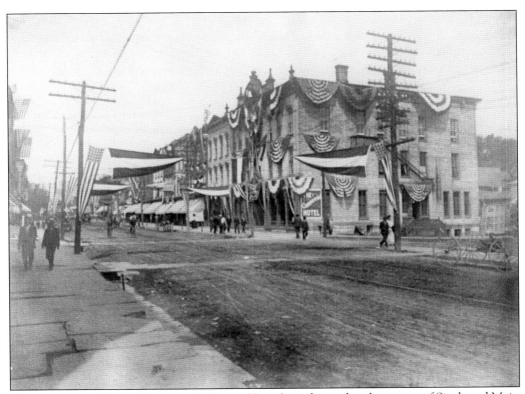

The Commercial Hotel (formerly the Coyne House) was located at the corner of Sixth and Main Streets. These decorations were placed in honor of Old Home Week in July 1909.

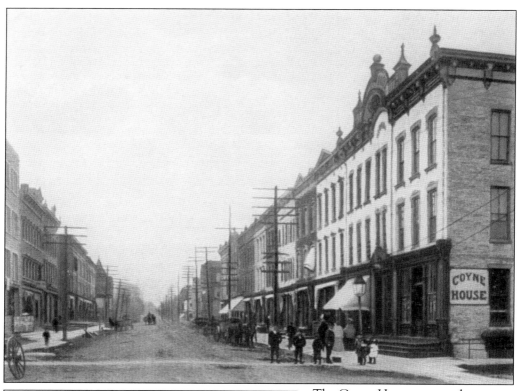

The Coyne House was on the corner of Sixth and Main Streets. Through the years, some of the businesses that have occupied the building include Grants, McCrory's, and (currently) Mommy & Me and the Furniture Warehouse.

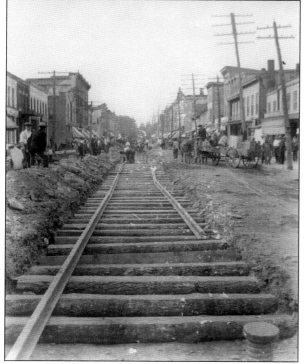

In 1912, a proposal called for a trolley to run between Honesdale and Hawley. However, the trolley project was never completed, although the tracks were dug and bricks were laid. Main Street was originally dirt, then filled with planks put down for wagons. It was later paved with bricks and, finally, asphalt.

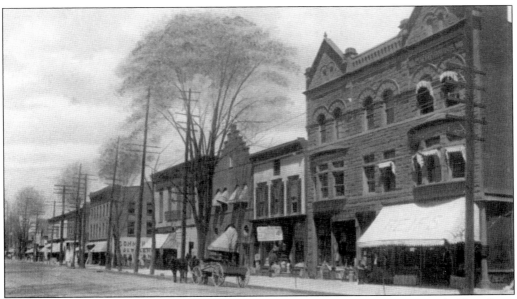

This Louis Hensel postcard shows the Eighth Street block of east Main Street. Reif's Shoe Store is the large building at right with two gables.

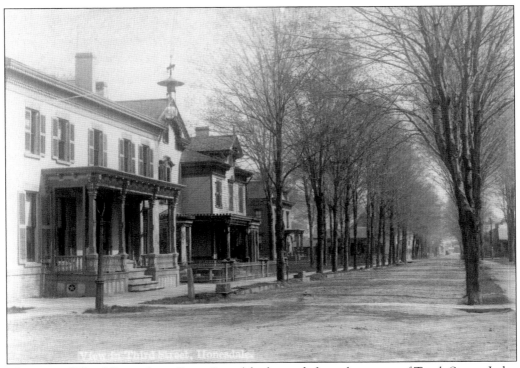

This view of Third Street (now Court Street) looks south from the corner of Tenth Street. Judge Wallers's house and Foster's stone house are on the left. Samuel Dimmick's home is partially visible. The dirt streets, lined with trees, went around the park.

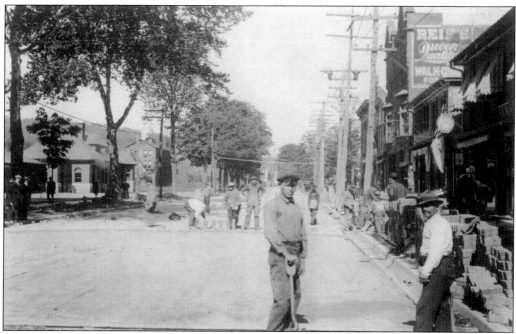

This image shows bricks piled on both sides of Main Street, with the train station at left. By day, men laid the bricks by hand, and in the evening, people would come and take the bricks. Yolanda Franco lived on Main Street for almost all her whole life and said she chased people with her broom when she saw them removing bricks.

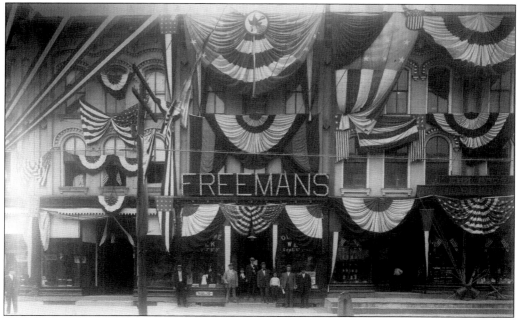

A group of men and boys stands in front of the Freeman's department store during Old Home Week. Freeman's was located on the Keystone block of Honesdale. In 1992, this building was demolished to make way for the Park & Shop lot.

In this view, Church Street, originally called Second Street, is dirt. The building at right is the Zenas H. Russell home, which was purchased by Margaret Rickard Murray and her son Robert J. Murray in 1920. It is currently the home of *Highlights for Children*.

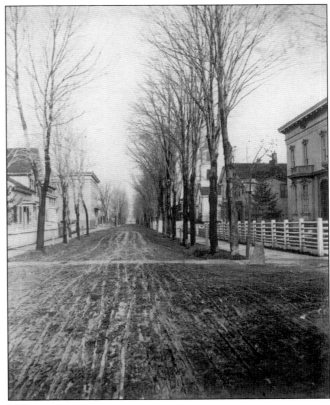

The Dimmick family lived at this home, located at the corner of Ninth and Church Streets, before it became the Park Hotel. Note the ornate fence around the house; many families had fences to keep livestock out of their yards when the animals were driven to market.

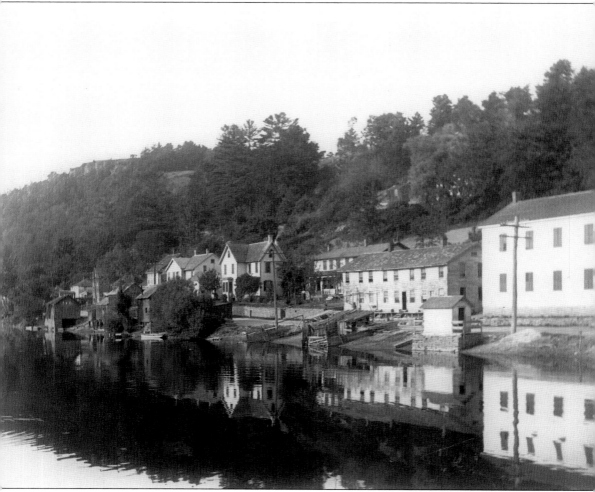

This image shows the Lackawaxen River and homes along Riverside Drive, which was also called Lady Wood Lane and River Street.

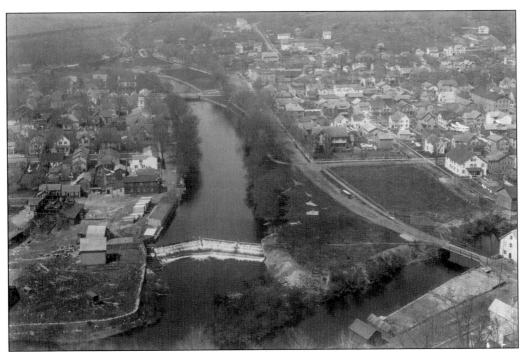

This view is from Irving Cliff. Just below the dam is where Dyberry Creek joins the Lackawaxen River. The area now known as Honesdale was originally called Dyberry Forks. The road on the right is Park Street, and the large grassy area is where the Pennsylvania State Armory was eventually built.

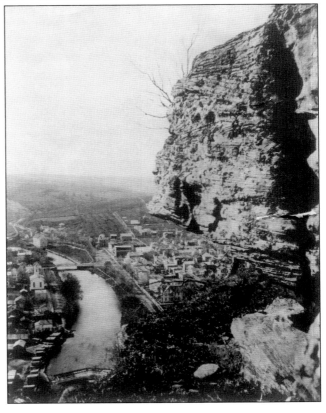

Irving Cliff was named after a friend of Philip Hone's—the author Washington Irving, who is best known for writing "The Legend of Sleepy Hollow." This photograph captures a side view of the cliff, where there is a rock formation that some people think resembles a profile of Abraham Lincoln.

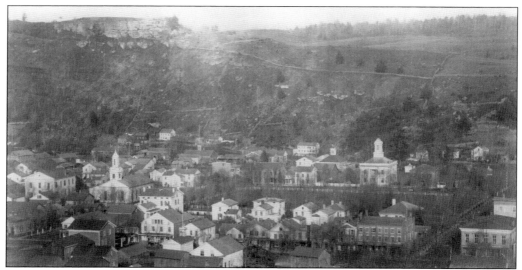

This aerial photograph of Honesdale shows Irving Cliff in the distance. The square building with a tower on top is the original wooden Wayne County Courthouse. Central Park, located directly in front of the courthouse, is fenced in to corral livestock. The white building at left, with a steeple, is the original wooden First Presbyterian Church of Honesdale.

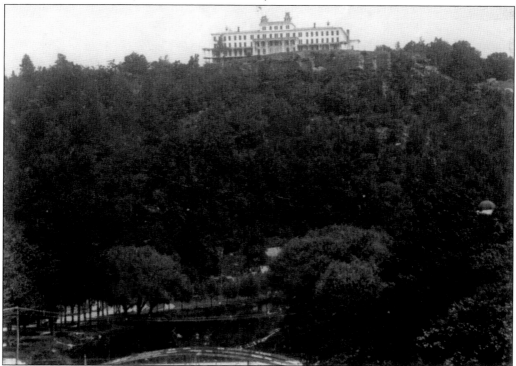

This view from the Main Street bridge shows the elegant Irving Cliff Hotel before it was destroyed by fire in 1889. In the foreground is the Court Street pedestrian bridge over the Lackawaxen River, which washed away during the 1942 flood. Today, a lighted Christmas star and Easter cross can be seen atop the cliff during those holiday times.

The beautiful Irving Cliff Hotel, which was built to accommodate 200 guests, never opened. On May 28, 1889, at 10:00 p.m., the hotel caught fire and was a total loss within two hours. All attempts to rebuild were unsuccessful. Many years after the fire, an oversized key to Room 57 was found where the hotel stood atop Irving Cliff; it is shown below. At right, employees and investors of the hotel are pictured on the hotel's porch shortly before the fire.

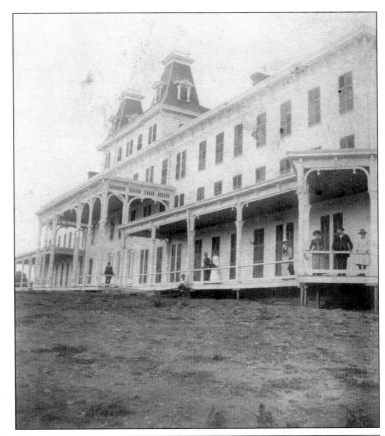

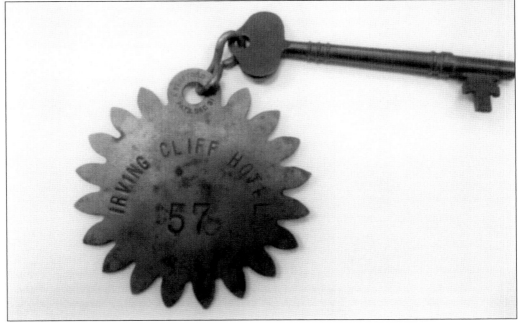

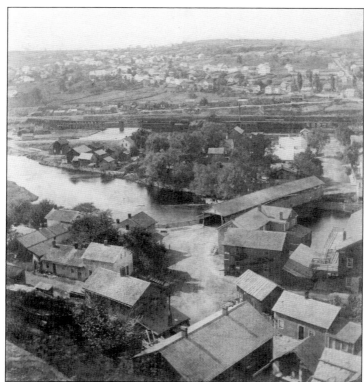

The Herman Covered Bridge, at center right in the photograph, was located across the Lackawaxen River at Fourth Street. The bridge was named for the Herman Carriage Shop, which was situated at the bottom of Cliff Street in the current location of Fritz Brothers Well Drilling. The span was replaced around 1901–1902.

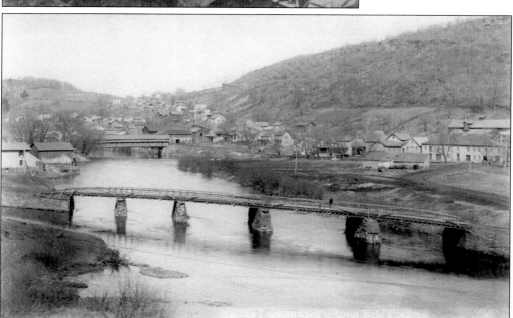

In this image, the Delaware & Hudson Canal Company's towpath bridge crossing the Lackawaxen River is in the foreground, and the Herman Covered Bridge and Irving Cliff are in the distance. The grassy area at right, where Lincoln School was once situated, is now the location of the Super Duper Grocery Store.

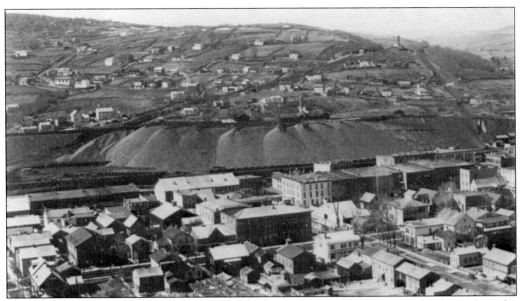

The middle of this photograph features the large stockpile of coal waiting to be shipped on the Delaware & Hudson Canal. The coal would pile up during the winter months, when the canal was frozen but the mines and the railroad continued to operate.

The Erie Freight House was located on Main Street. The building next to it currently houses the Trackside Grill and business and professional offices.

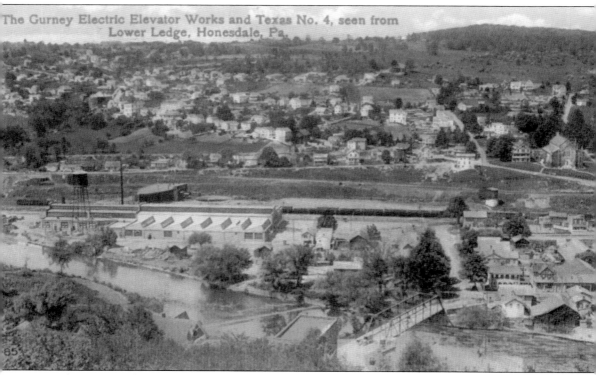

This view of Honesdale shows the Fourth Street bridge and the Gurney Electric Elevator Company.

Four

BUSINESS AND INDUSTRY

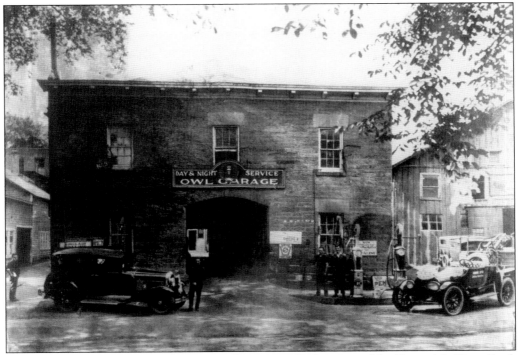

The Owl Garage was on Church Street at the present-day location of the Honesdale Dime Bank parking lot. This stone building was originally the Whitney Livery Stables, which were open 24 hours a day. People rented horses and carriages at the livery or boarded their horses while they were in Honesdale; the horses that pulled the Silsby fire apparatus were stabled in the livery. Whenever the horses heard the fire alarm, they would run directly to the fire station. The Owl Chrysler Garage was the final business housed in this building before it was torn down in October 2006. (Courtesy of Gary Goodman.)

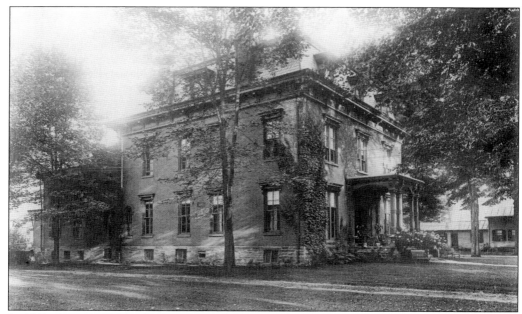

In 1919, Augusta Kuhback, the owner of the Samuel E. Dimmick House, sold the house to the Wayne County Memorial Hospital Association for $10,000. The 22-room Wayne Memorial Hospital was dedicated to the soldiers and sailors lost in World War I. Eventually, the hospital needed more space and built a new structure on Park Street in 1951. The hospital then sold Dimmick House to the Honesdale Gospel Tabernacle, which used it as a church for 40 years. Today, it serves as an annex to the Wayne County Courthouse and is used as an office building.

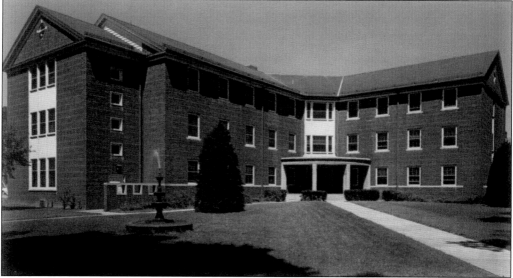

The original Wayne Memorial Hospital, dedicated on September 29, 1920, was located at the corner of Ninth and Court Streets. The new hospital building (pictured), an 80-bed facility on Park Street, was considered the most modern medical center in the Pocono Mountains region at the time. Since then, the hospital has undergone several major additions to keep pace with the growing community.

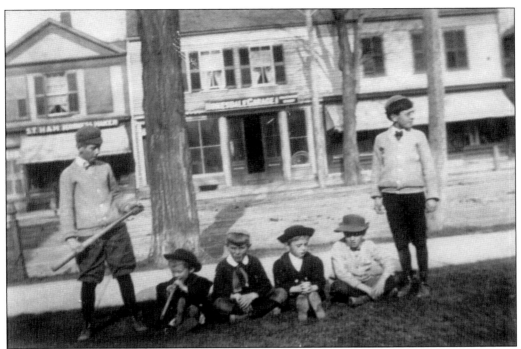

In this picture, taken at 1128 Main Street, these boys appear to perhaps be looking for some other kids in order to play a game of baseball. Boys used to wear dresses until they reached about the age of four, then they would switch to wearing short pants or knickers. They wore knickers with knee socks; it was a rite of passage for young men around the age of 14 to begin wearing long pants.

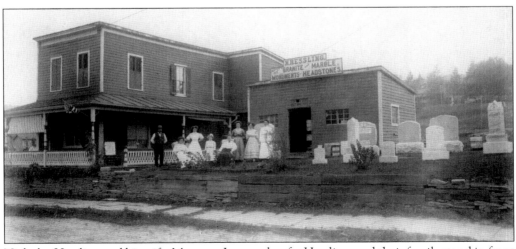

Nicholas Hessling and his wife, Margaret Langendoerfer Hessling, and their family stand in front of the Hessling Funeral Home at 428 Main Street. Their monuments and headstones business was attached to the funeral home.

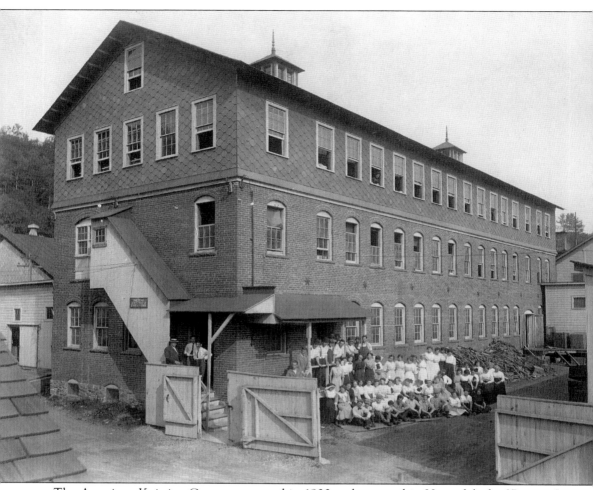

The American Knitting Company opened in 1900 and operated in Honesdale for 37 years. It was located at Twelfth Street, on the Lackawaxen River, at Industrial Point. These factories, an important part of the community at the time, employed many Honesdale residents.

W.H. Varcoe is pictured at his business, the Varcoe Printing House, demonstrating how to use an old printing press. Starting in 1916, Varcoe printed the *Booster*, a free newspaper distributed throughout Honesdale. On Saturday mornings, people would look for any misspelled words, because finding 10 misspelled words meant one could win a free ticket to the movies.

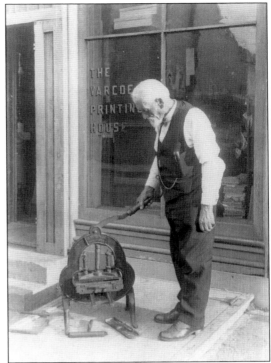

This is an early photograph of the Honesdale National Bank, which celebrated its 175th anniversary in 2011. In 1863, it was renamed from Honesdale Bank to Honesdale National Bank when Zenas Russell became president.

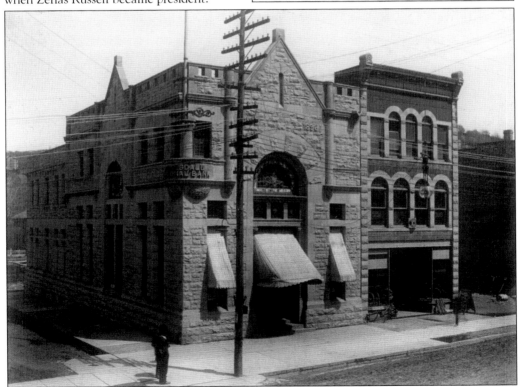

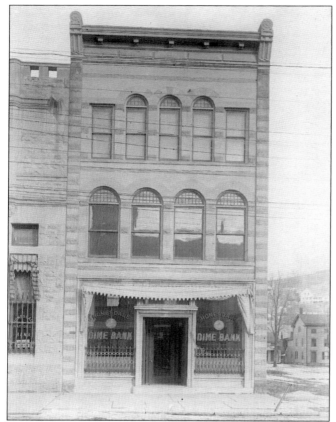

The Honesdale Dime Bank, established in 1906, was originally located next to the Honesdale National Bank. The Dime Bank erected a new building on Church Street in 1985. Clarence L. Wright was president of the bank from 1948 until his death in 1968.

The S.E. Dimmick Office Building, located on Tenth Street, was purportedly the site of a meeting used to organize a movement to nominate Abraham Lincoln for the 1860 presidential election. There are still some questions about the accuracy of this rumor.

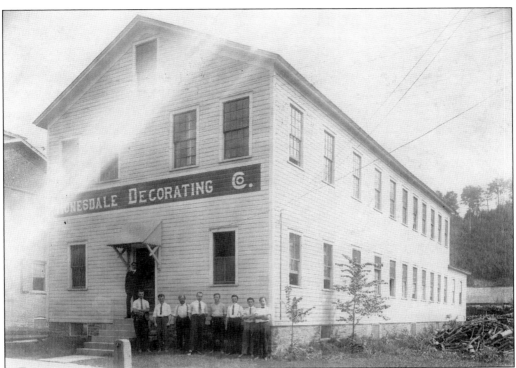

The Honesdale Decorating Company employees pictured here are, from left to right, Carl Prosch, manager and owner; Ed Linke, acid dipper and choreman; Gustave Kettle, foreman and highly skilled decorator; Frank Milde, glass engraver; George Ripple, shipping clerk; Fred Crist, decorator; Hugo Papert, highly skilled decorator; Fred Martin, artisan and decorator; and Nicholas Stegner, assistant foreman, artisan, and decorator.

Located at the corner of Main and Chapel Streets, the McKanna Cut Glass Shop also owned the McKanna Cooperage next door, which made barrels used to pack glass and fragile items for shipping. The McKanna Cooperage is still located on Main Street and hosts many community events, so people can still enjoy the building.

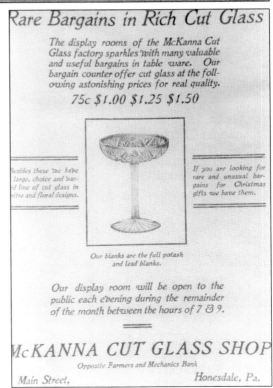

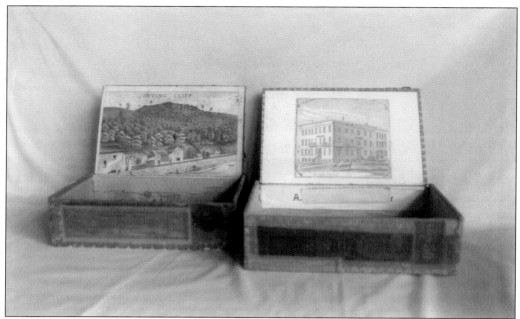

These two cigar boxes contain images of Irving Cliff (left) and the Allen House. They were manufactured by local tobacconist Albert Eberhardt. Traditionally, one would see a wooden statue (usually depicting an American Indian) positioned outside a shop that sold tobacco.

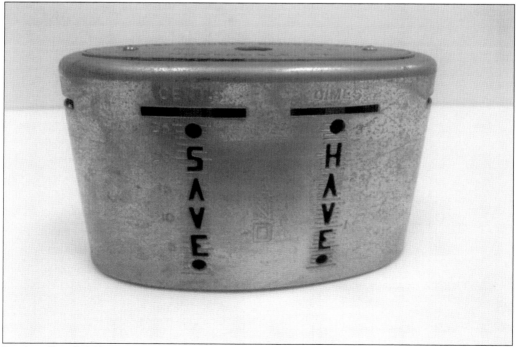

Banks offered different incentives to encourage savings. This is a coin bank from the Wayne County Savings Bank; above the slots, the words *cents* and *dimes* are meant to inspire people to both "save" and "have" money.

This two-story building at 642 Park Street was occupied by the office of dentist Dr. Newton Mullins in the 1920s. Local residents recall going to Dr. Mullins and paying a dime to have a tooth pulled.

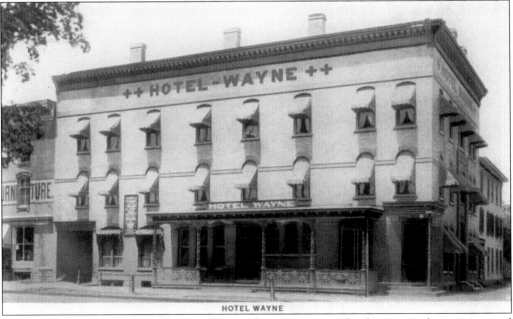

The Hotel Wayne was originally a smaller wooden structure used to house canal executives and workers. Years later, it was renovated and enlarged as shown in this postcard. The building at left housed Brown's Furniture.

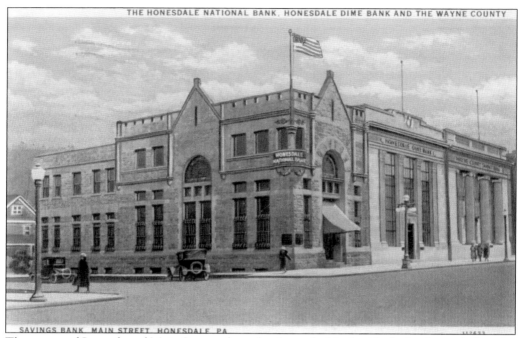

SAVINGS BANK, MAIN STREET, HONESDALE, PA.

The corner of Seventh and Main Streets always has been the block with the banks, including the Honesdale National Bank, Honesdale Dime Bank, and the Wayne County Savings Bank.

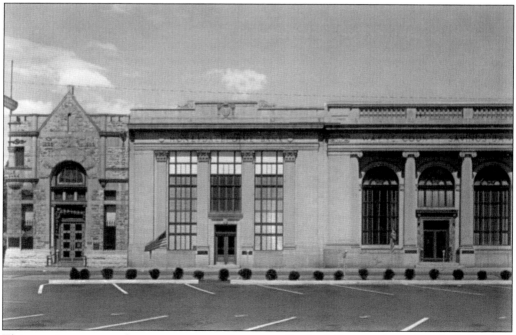

This massive stone and cement structure, known as Banker's Row, took up the whole block at Seventh and Main Streets. The three banks are, from left to right, the Honesdale National Bank, Honesdale Dime Bank, and the Wayne County Savings Bank.

In 1871, the Wayne County Savings Bank started out in the Weston Building and moved two more times before settling on Main Street at its current location.

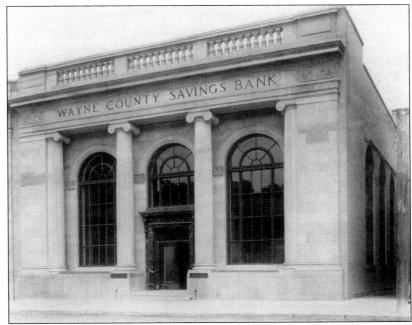

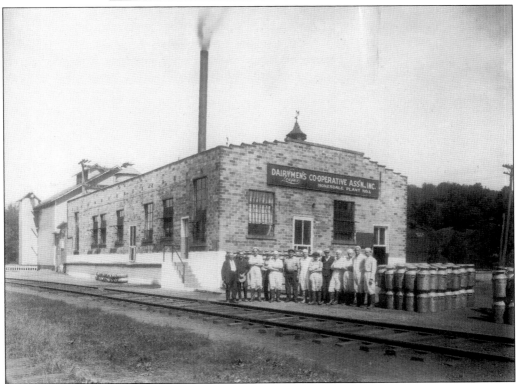

The Dairymen's Co-operative Association was one of the creameries in the area; note the large milk cans stacked outside the building. This creamery was located close to the train tracks so dairy products could easily be shipped to areas such as New York and New Jersey.

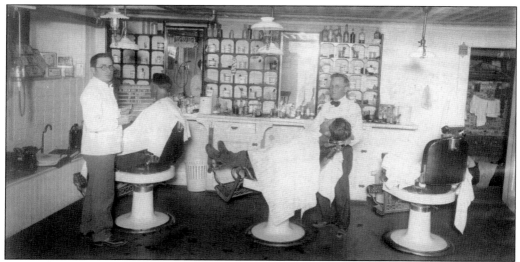

Theobald's Barbershop was located on the corner of Seventh and Main Streets. J. Alfred Theobald (left) cut hair with his father, Jacob Theobald (right). Theobald's was a place for local men to get together and catch up on the gossip in town. A barbershop in still in operation at the same location, but it is now called Mick's.

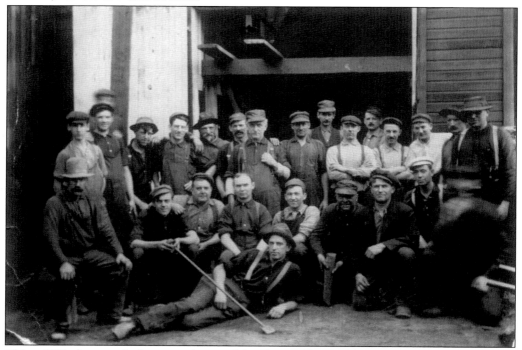

This c. 1911 photograph shows employees of the Gurney Electric Elevator Company. The Gurney plant was erected for $250,000 and employed about 350 men. Honesdale had a board of trade to help secure new business in town. I. Blumenthal and Robert J. Murray played a big part in securing Gurney on a five-acre plot on Fourth Street. Gurney elevators were made in Honesdale and shipped all over the world. Local businessman Gary Goodman stated that while in Germany, he was in an elevator that had a plaque reading: "Made by the Gurney Elevator Company, Honesdale, Pa."

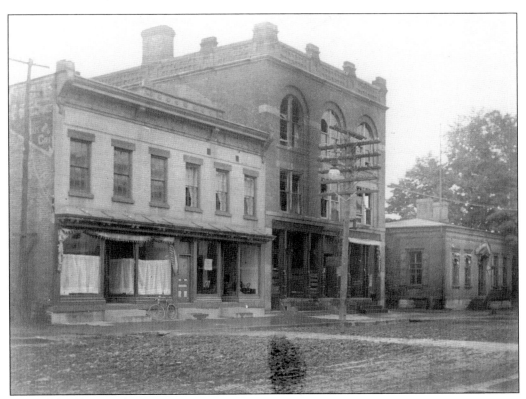

The tall building in the center is the former Wayne Independent Building, which is shown after a fire on September 24, 1907. The building at left, with the curtains, was a pool hall and later became the Maple City Diner and then the Trackside Grill. The building at the right was the Delaware & Hudson Canal Company building, now the Wayne County Historical Society's museum.

This is a view of back of the Florence Silk Mill on Willow Avenue. The Lackawaxen River is in the foreground, and Irving Cliff is in the distance. Many people who worked in the local factories would get paid based on the number of pieces they completed.

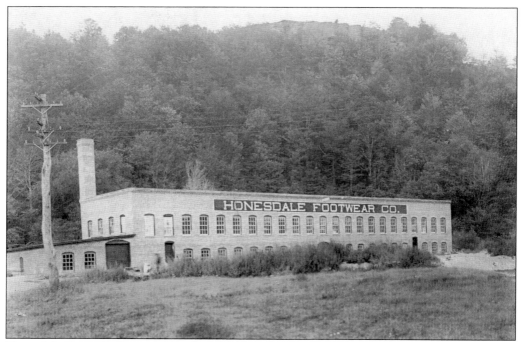

Honesdale Footwear Company was located on Park Street across from the Pennsylvania National Guard Armory (now the YMCA). This was only one of seventeen shoe factories located in Honesdale. On Sundays, the fire companies would practice drills by rescuing volunteers from the roof of the shoe company. After a fire in 1913 that caused extensive damage, this property was sold to the Honesdale Union Stamp Shoe Company, known locally as HUSSCO.

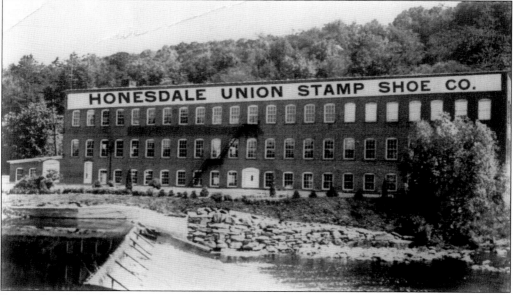

During lunch breaks, many local students would go fishing at the dam in the Lackawaxen River in front of the Honesdale Union Stamp Shoe Company. If they caught any fish, they would tie them up near the dam and come back after school to fetch them.

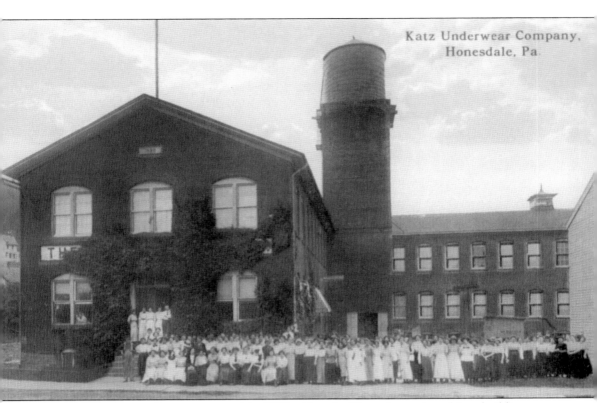

Katz Underwear Company, Honesdale, Pa.

The Katz Underwear Company started in 1899 with only 10 employees based in a building on Honesdale's Main Street. In 1921, the company claimed to have the largest factory in the world in one building. Through the years, the company kept growing and employing more people. The factory could produce 17,000 garments per day, mostly lingerie. Katz, which had contracts with the Red Cross and the federal government to make items for the military, remained one of the largest employers in Wayne County until the factory closed in 1992.

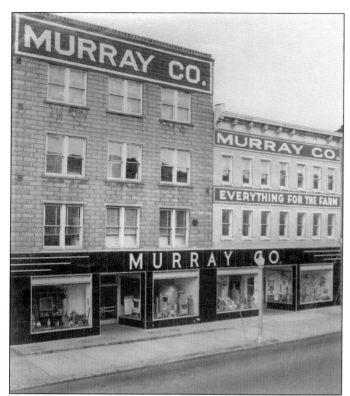

The Murray Company, owned by generations of the Murray family, sold everything from silos and farm equipment to toys for children. At Christmastime, children could sit on Santa's lap on the store's third floor.

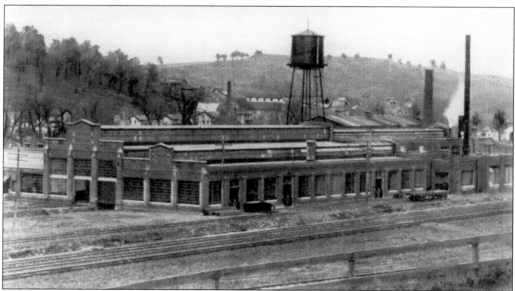

The National Elevator and Machine Company succeeded the Honesdale Iron Works after a fire in 1887. It became the Gurney Electric Elevator Company in 1905. Elevators made in Honesdale can be found in many other countries. The factory was located next to the train tracks so material could be easily shipped in and out of town. This building was located on Fourth Street where the CVS Pharmacy is today.

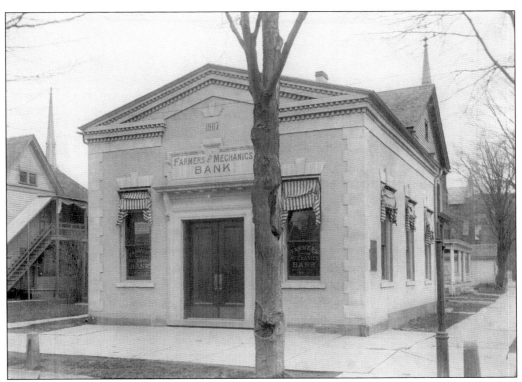

The Farmers and Mechanics Bank at the corner of Tenth and Main Streets replaced the Honesdale National Bank after it moved to its present location. Several other banks have also stood at this location.

The Great Atlantic & Pacific Tea Company grocery store was located in the Eagle Building on Main Street. The Atlantic & Pacific Tea Company was the first national grocery chain in the United States. Salesmen would take the store's items on horse-drawn wagons and head out to start new Atlantic & Pacific stores. The first store started by selling tea, coffee, and spices at a value price.

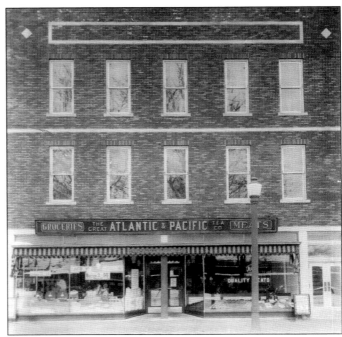

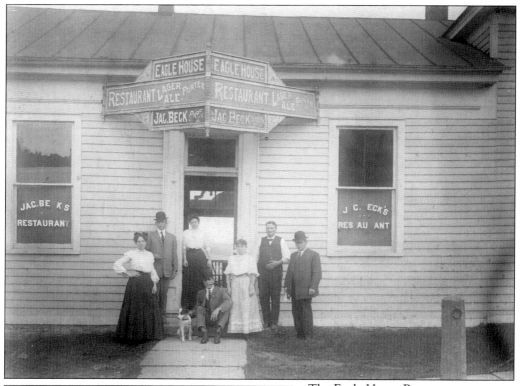

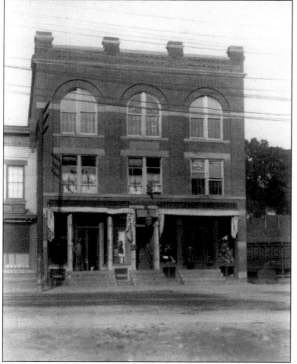

The Eagle House Restaurant, located on Terrace Street, was owned by Jacob and Anna Beck. The building was originally a hotel, then a saloon, and, later, a grocery store. When locals went into the grocery store, they could still see the bar from when it was a saloon.

This image shows the Wayne Independent Building in the early 1920s. Over the years, this building contained several businesses and organizations, including the Grand Union Tea Company, the Odd Fellows hall, several doctors' and dentists' offices, and the Honesdale Chamber of Commerce. This structure is still standing and is located next to the Wayne County Historical Society.

Rolls of paper for the *Wayne Independent* newspaper were delivered by train. Men would use sticks, such as those shown in this photograph, to move the large, heavy rolls. The *Wayne Independent*, the only newspaper still printed in town, is now located on Eighth Street. Pictured here are, from left to right, Earl Branning, unidentified, unidentified, and ? Stahl.

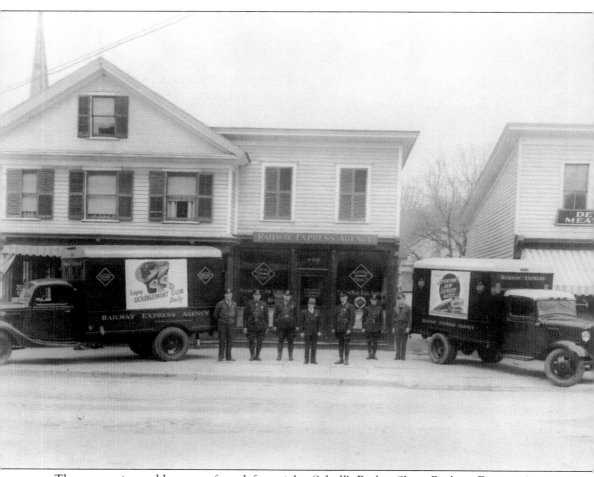

The stores pictured here are, from left to right, Scholl's Barber Shop, Railway Express Agency, and Dein's Butcher Shop. These businesses were located on the 900 block of Main Street. The Railway Express would travel to Scranton to pick up packages and bring them back to Honesdale for home delivery.

Five

PUBLIC BUILDINGS

The first borough meeting held in the new Honesdale City Hall was on July 3, 1893. The borough council borrowed $15,000 in 1891 to construct the public building, firehouse, fire bell, and furnished council rooms. The basement was used as a jail, and for many years, part of the building was a home for Protection No. 3 Fire Company and the post office. Above the large central arch is a balcony where dignitaries made public speeches and Santa Claus threw popcorn balls to children during Christmastime. The building has since been renovated and the two cupolas removed.

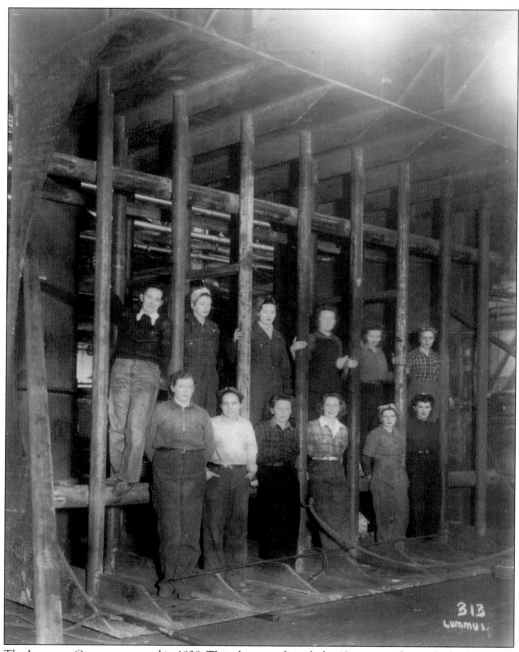

The Lummus Company started in 1938. This photograph includes 12 women who worked at Lummus. They were building 32,600 square feet of condensers for the Commonwealth of Pennsylvania, to be shipped from Honesdale on the railroad.

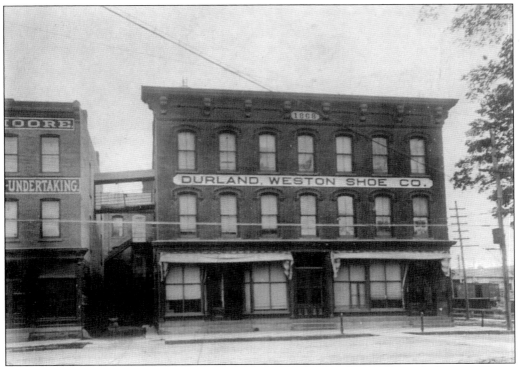

The Durland Weston Shoe Company, located at Chapel and Main Streets, made shoes and boots for men, women, and children. The company's 170 employees could make 720 pairs of shoes per day. The building at left housed the William T. Moore Furniture and Undertaking business. Note the second-story bridge between the two buildings.

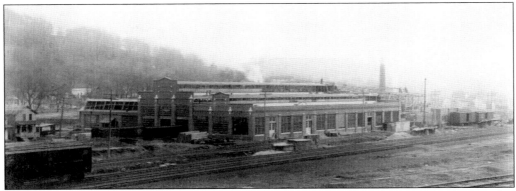

In 1905, the Gurney Electric Elevator Company started in an industrial area at the south end of Main Street. It was previously the site of Honesdale Iron Works and, later, the National Elevator Company. Canal boats were once made at this site, but canal-boat building was later relocated to Hawley.

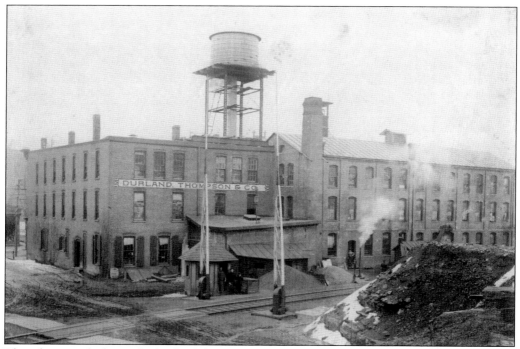

This photograph shows the back of the Durland, Thompson & Company building, which was located next to the train tracks. In the foreground of the photograph are railroad crossing gates and the gatekeeper's hut. Several of Honesdale's factories had water towers in case of fire. Some other local businesses that had these towers included Katz Underwear Company, Gurney Electric Elevator Company, and the Florence Silk Mill. A fire usually caused a lot of damage, because the fire equipment of the time was not very good and water pressure was not very strong. Locals recall that sometimes water would freeze during the cold months, so fire equipment was not always helpful. Ed Guinther later talked about how he would have to clean all the windows in this building for 8¢ an hour.

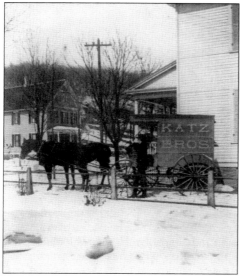

Katz Brothers, a large department store on Main Street, also sold groceries and would deliver products to customers in this horse-drawn wagon. Before the advent of the automobile, businesses often used horse-drawn wagons for deliveries, and in the winter, they would utilize horse-drawn sleds.

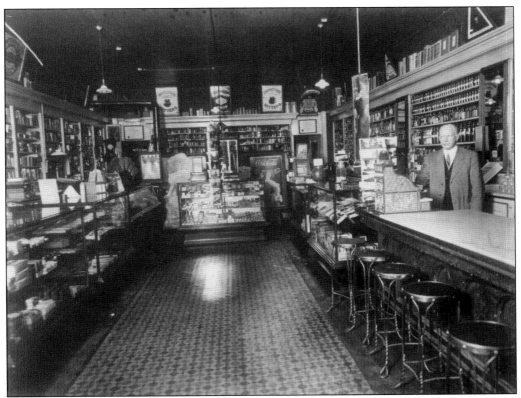

At Chambers Drug Store, located at 871 Main Street, and other local pharmacies, one could get medicine and then pull up a stool, have a soda, and hear about all the local news. Many local children would stop in for penny candy or to sit and share a soda with a friend.

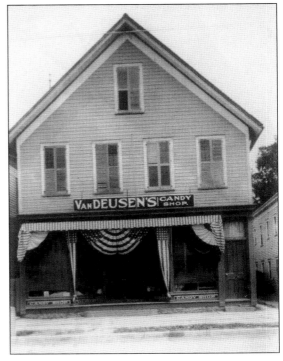

In 1925, Van Deusen's Candy Shop, located at 1037 Main Street, was a very popular store. Before going to the Lyric Theater, moviegoers would first stop at Van Deusen's for a nickel bag of broken candy scraps. "Garage Mix" candy was created when the mechanics at Matter's Garage would purchase chocolate babies and peanuts and heat them up on car engines.

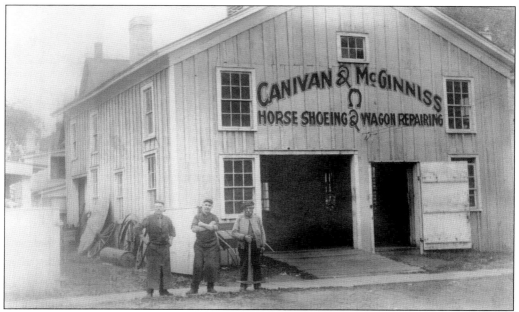

Canivan & McGinniss was located on Sixth Street next to the Coyne House. Hotel guests, as well as local residents, could get their wagons repaired and horses shod here.

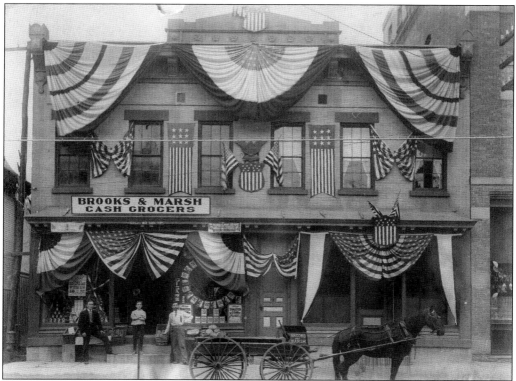

Brooks & Marsh Cash Grocers, located at 1125 Main Street, is pictured during Old Home Week, which Honesdale celebrated from September 6 through September 9 in 1909.

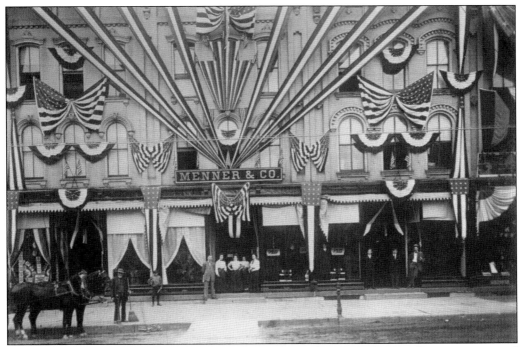

The staff at Menner & Company department store, located at 646–654 Main Street, are pictured in front of the store during Old Home Week. Honesdale went all out for Old Home Week—huge flags and bunting were displayed all over the town's storefronts.

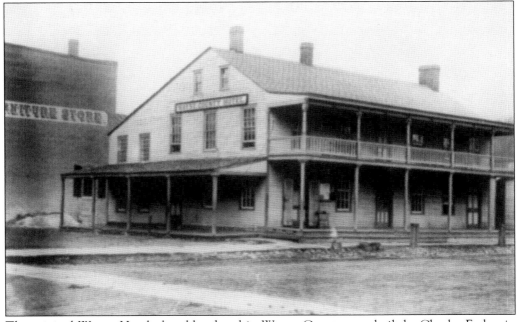

The original Wayne Hotel, the oldest hotel in Wayne County, was built by Charles Forbes in 1827 to provide housing for executives of the Delaware & Hudson Canal Company. Honesdale's first post office was located in the hotel.

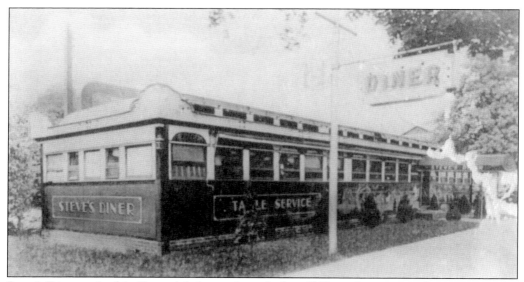

Steve's Diner arrived in Honesdale by truck in the late 1930s and was situated on an empty lot at 920 Main Street. The incorporation of the "railroad car look" and use of the word *diner* were efforts by manufacturers to streamline designs identified with speed and efficiency. The enlarged and renovated structure now houses Scarfalloto's Town House Diner.

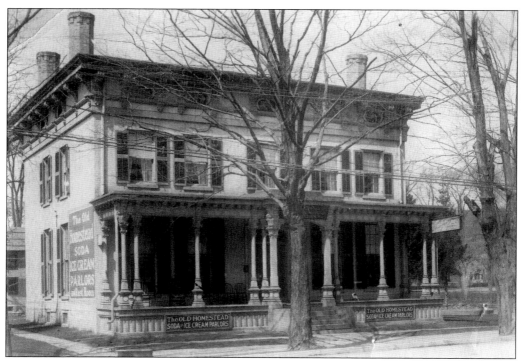

Originally the home of Coe Young, the Old Homestead, built in 1849 on West Main Street next to the Lackawaxen River, was a place where a soda fountain and tennis courts were available. It was torn down in 1934 and replaced with Fowler's Service Station.

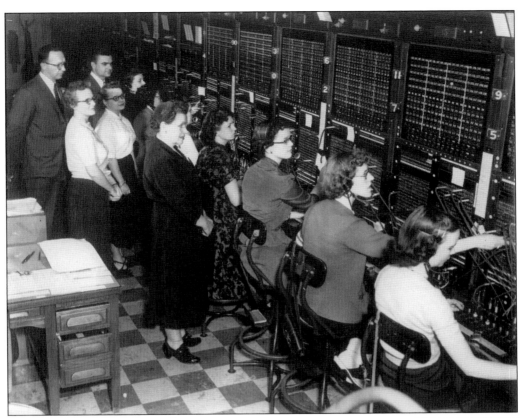

The Pennsylvania Telephone Company was located on the second floor above Jerry Land Jewelers at the corner of Main and Ninth Streets. The operators were the first to talk to soldiers when they made phone calls to home. They even served as babysitters sometimes, when a mother would ask an operator to talk to a child for a few minutes so she could run out to the barn.

Kinsman's Repair Shop was built in 1946 along the old Delaware & Hudson Canal bed. The men in this photograph are, from left to right, Fred Brill, Willis Gummoe, and Robert Brundage. Kinsman's still has a storefront on Main Street, where it sells tractors and tractor parts.

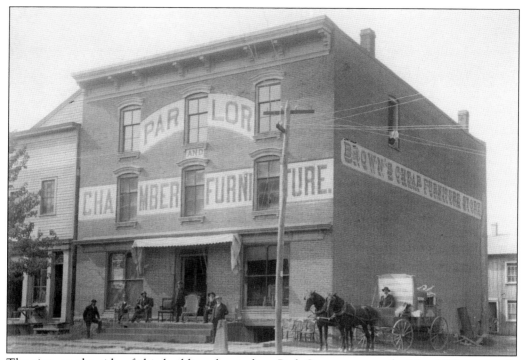

The sign on the side of this building, located on Park Street next to the Hotel Wayne, reads "Brown's Cheap Furniture Store." This building also served as a funeral parlor; at that time, it was common for furniture-makers to also build caskets. During the early days of the business, they would make deliveries via horse-drawn wagon.

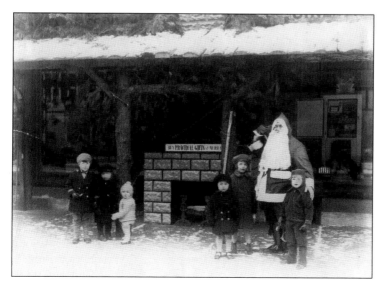

Santa and some children are pictured in front of the Murray Company in 1931. Christmas gifts, farm supplies, household items, and many other things could be purchased at Murray's. To this day, local residents will talk about their fond memories of going to see Santa on the third floor at Murray's.

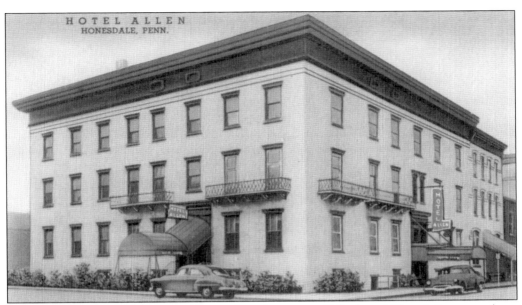

The Hotel Allen, built in 1858, was located on the corner of Ninth and Church Streets and was the first concrete hotel in Pennsylvania. It was destroyed in 1978 by a tragic fire in which 13 people perished. The Honesdale Dime Bank is now located at this site.

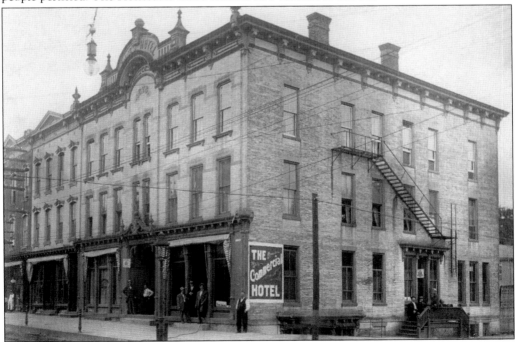

The Commercial Hotel, located on the corner of Sixth and Main Streets, was previously the Coyne House. The original wooden structure was destroyed by fire on January 8, 1875, and owner Michael Coyne had the hotel rebuilt with brick. This location originally contained the Honesdale House, which was torn down by Coyne to build his new hotel. In 1909, the Coyne family sold this building to Charles and May Weaver, who renamed it the Commercial Hotel.

The C.W. Smith & Company gift shop was located on the corner of Eleventh and Main Streets. Carrie Smith is pictured here. This was the place to go for gift items and greeting cards.

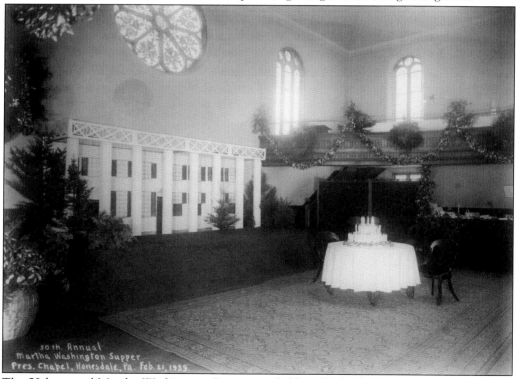

The 50th annual Martha Washington Supper was held at the Presbyterian chapel on February 21, 1939. This turkey dinner was held in honor of Washington's birthday. The church used the event as a fundraiser, and it was always well attended.

Eight unidentified men are pictured at the 1904 dedication of St. John's Evangelical Lutheran Church, at the corner of Seventh and Church Streets. The original church was located on the east side of Church Street, between Seventh and Eighth Streets, on property that is now owned by *Highlights for Children*.

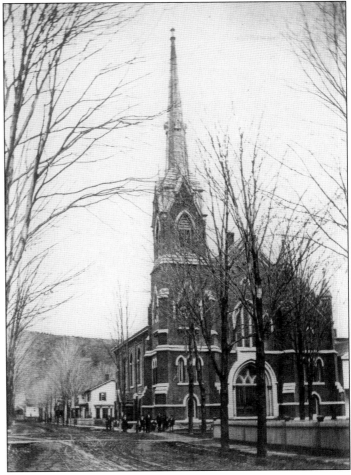

The United Methodist church, which started in 1872 at the corner of Church and Tenth Streets, has the distinction of having the tallest steeple in town. The Methodist Episcopal denomination was one of the earliest in Wayne County, and meetings were originally held in the homes of church members.

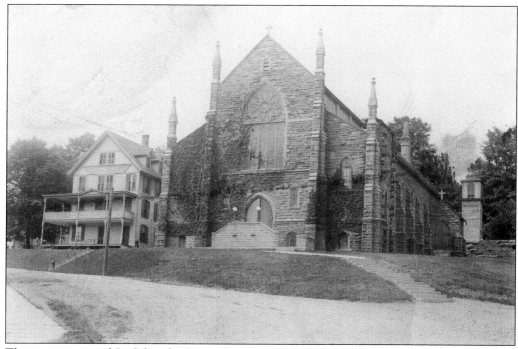

The cornerstone of St. John the Evangelist Roman Catholic Church was laid on October 13, 1876. A statue behind this church indicates the location of the original wooden church, which served Honesdale's Irish community. Rev. John J. Doherty, who was in charge of the parish from 1859 to 1896, had a large impact on Wayne County.

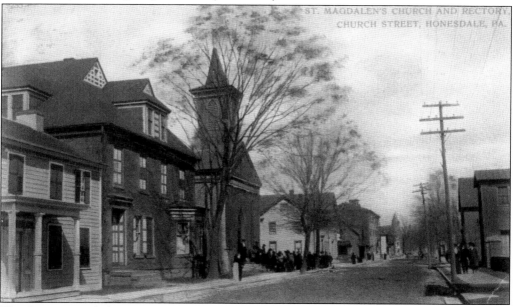

The German Catholic congregation of St. Mary Magdalen's Church organized in Honesdale in 1833. After a fire destroyed the church on Seventh Street, the congregation built a new church (pictured) at the corner of Church and Fifth Streets in 1860.

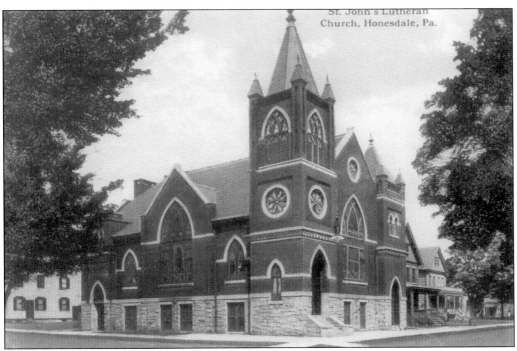

The corner of Church and Seventh Streets became the second location for St. John's Lutheran Church. When the Lutherans first came to town, they were known as the German Evangelical Lutheran congregation, which started in 1845. As time went on, the congregation dropped the word *German* from its name.

In 1837, Jason Torrey donated land on the north side of Central Park for the construction of the First Presbyterian Church of Honesdale. The church was organized in 1829 in a boardinghouse located at the industrial point where the Lackawaxen and Dyberry Rivers join that was later known as the Tabernacle. The fence that surrounded Central Park is shown in front of the church in this photograph.

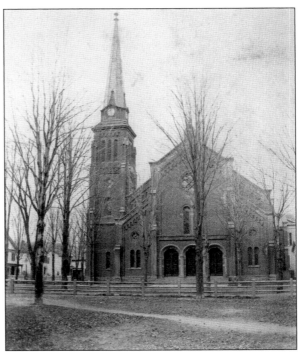

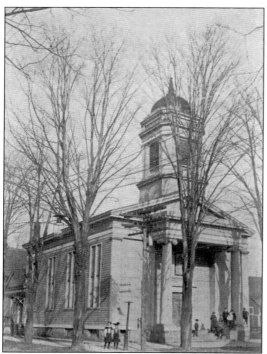

The First Baptist Church of Honesdale, at the corner of Church and Twelfth Streets, formally organized in 1842. Prior to that, the congregation held services in the Honesdale Schoolhouse and the Tabernacle.

The Grace Episcopal Church, built with local sandstone in 1854, is located on the south side of Central Park on land donated by the Delaware & Hudson Canal Company. The beautiful spire was added in 1879 as a memorial to Zenas H. Russell, an organizer of the original Honesdale church and a lifelong vestryman and warden. Russell was in the mercantile business and owned a store that later became the Delaware & Hudson Railroad station.

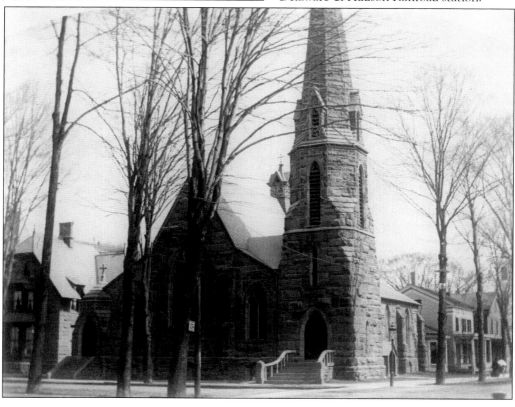

The Delaware & Hudson Canal Company donated the land for Temple Beth Israel in 1856. One of the stipulations of the land donation was the requirement of a steeple that would emulate other community churches. This has always claimed to be the smallest Jewish temple in the United States—and the only one with a steeple.

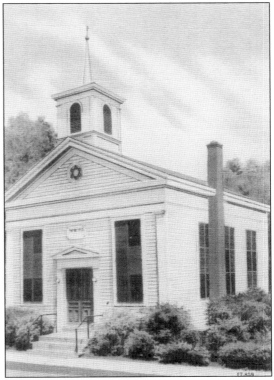

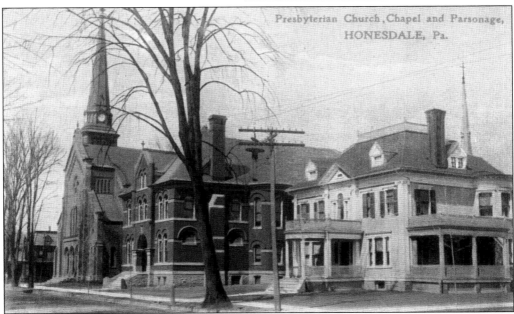

Presbyterian Church, Chapel and Parsonage, HONESDALE, Pa.

The Presbyterian church, chapel, and parsonage are situated on Tenth Street across from Central Park. The chapel was built by R.H. Brown in 1891 for $20,200. The reading room was open to the public and was considered the first library in town. The parsonage was the pastor's residence, and the congregation contributed almost all of the $4,819 used to build it in 1898.

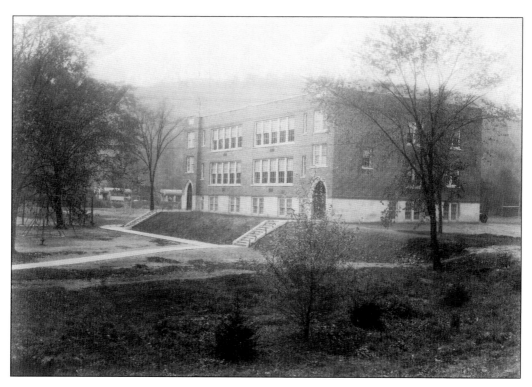

Stourbridge Elementary School (above), located on Park Street, and Lincoln Elementary School (below), situated on Willow Avenue, were identical buildings. It was known to flood near Stourbridge Elementary, so it was built up on a bank. Stourbridge Elementary had at tunnel that went from the street to the school grounds, under the railroad tracks, so children would not have to cross the train tracks to get to school. The Stourbridge Elementary building is now used to house some Wayne County offices, and the Lincoln Elementary building has been demolished.

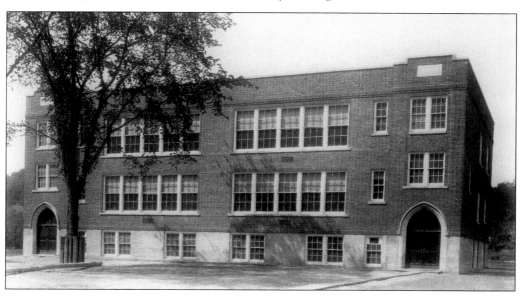

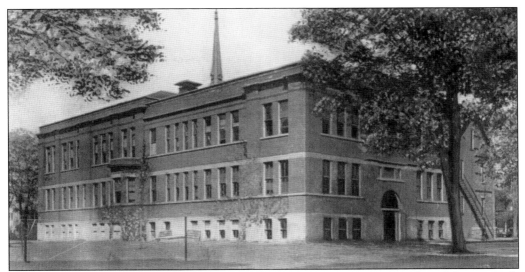

Honesdale High School, located on Church Street, was built in 1909 and used until the new high school on Terrace Street opened in 1959. The Church Street building was then renamed the J.J. Koehler School in honor of a longtime Honesdale educator and used to house the fifth and sixth grades. The school has since been demolished.

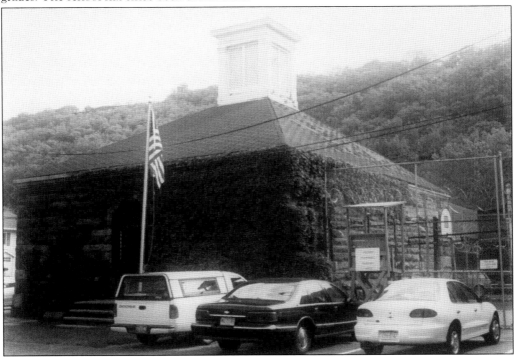

The Old Stone Jail, located next to the Wayne County Courthouse, was built in 1858, for $16,000, to replace the original wooden jail. The cells, which were small, damp, and bitterly cold in the winter, each contained an iron bunk and a chair. The jail was not secure; prisoners escaped through the roof, by digging through the floor, or through the doors and windows. It was condemned in 1936, and a new jail was erected.

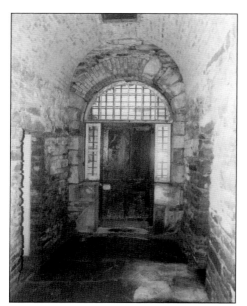

The interior of the Old Stone Jail was heated by a potbelly stove, but winters were still very cold. The sheriff's wife was responsible for cooking the meals and doing the laundry. In 2002, an agreement between the Wayne County Commissioners and the Wayne County Historical Society opened the historic jail for public tours.

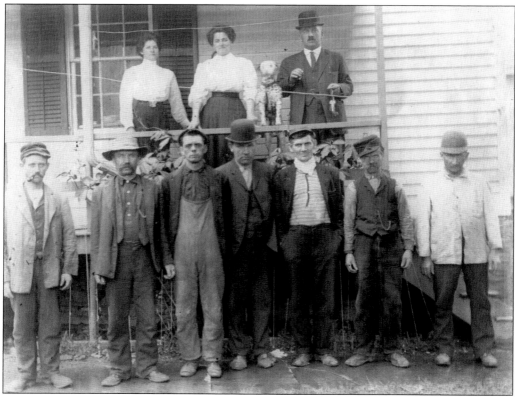

Wayne County sheriff Charles G. Armbruster, along with his wife and sister, poses for a photograph with some inmates from the Old Stone Jail. Prior to the building of the jail, an overflow of prisoners from the smaller wooden jail would necessitate them being shackled and housed on the second floor of the sheriff's home.

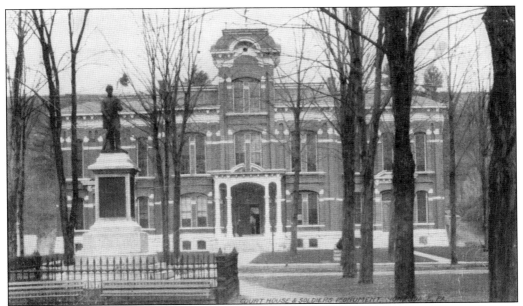

Construction started in 1876 on the replacement for the original wooden Wayne County Courthouse—this brick building, which is still in use today. However, due to taxpayer anger, as well as legal, financial, and political disputes, the city became entangled in what became known as the "Courthouse Wars." There was little progress on the structure until 1879, when the county commissioners resolved to complete the building. By 1880, the new courthouse, which cost $130,000, had become a reality. What seemed an extravagance in the 1870s resulted in a courthouse that remains a source of immense pride to county residents. The Civil War Monument, erected in 1869, stands in beautiful Central Park in front of the courthouse. It lists the names of the 353 soldiers and sailors who lost their lives during the war. There is a time capsule in the cornerstone of the monument, and another time capsule near the back of the monument will be opened in 2021.

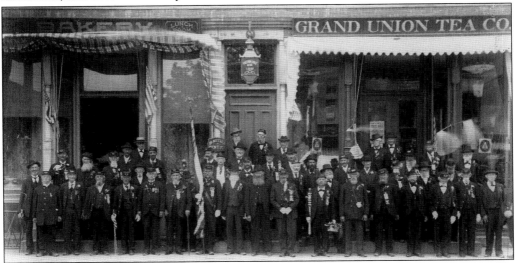

Members of the Capt. James Ham VFW Post No. 198 posed in front of the Grand Union Tea Company on Memorial Day in 1903. The VFW is still in existence on the second floor of this building and continues to serve area veterans.

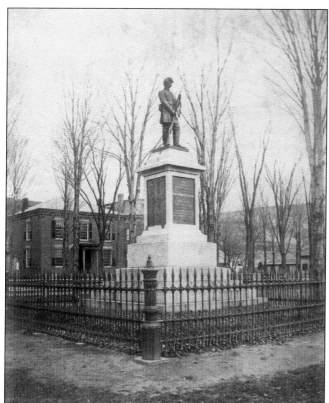

The Civil War Monument in Central Park was dedicated on September 9, 1869, by the Ladies' Monumental Association of Wayne County. The names of 353 Civil War casualties are listed on three sides of the monument. The fourth side of the monument is dedicated "to the Memory of our Dead who fell so That the government of the People, by the People and for the People should not perish from the Earth."

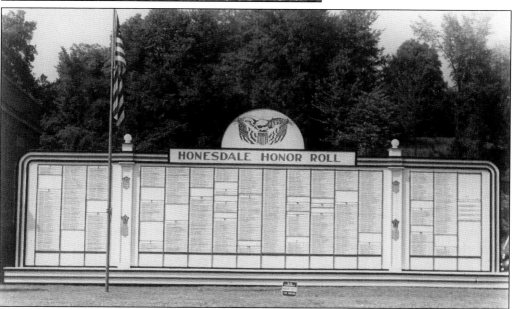

The Honesdale Honor Roll, once located on Main Street (where the post office is now), contained the names of 650 men and women who acted in the military service of the United States during World War II. The memorial no longer exists.

This house, now the home of the Wayne County Public Library, was built in 1869 by William Foster for $30,000. The bricks are believed to have been made in Honesdale brickyards. The basement is an architectural marvel. Massive stone pillars extend down the length of the main hallway, and huge archways divide the subterranean rooms. It is believed that this construction was deemed necessary due to the floods on the Lackawaxen River. After the deaths of the Foster family, the property was sold to Thomas B. Clark, owner of the T.B. Clark & Co. Glass Cutting Shop, which was known as "the university," since most glass cutters in Wayne County—other than those of the Dorflinger Shop—were trained there. After Clark's death, ownership transferred to his daughter, Faith Clark Morton, of the Morton Salt empire. She sold the property to the Wayne County Home Association in 1946, and it functioned as a retirement facility, Seven Maples, until 1988, when it was transferred to the Wayne County Public Library.

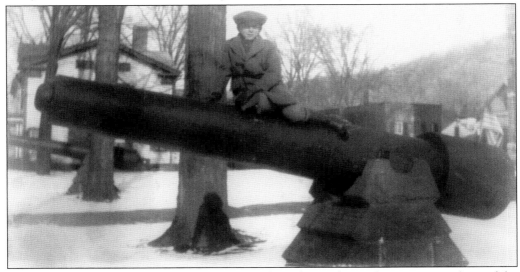

This is one of two 100-pounder Parrott cannons from the Civil War that once sat in front of the Wayne County Courthouse. They were presented to the Capt. James Ham Post No. 198 of the Grand Army of the Republic by the Department of the Navy on February 24, 1897. Both cannons were melted down during World War II when metal was needed for the war efforts. The boy on the cannon is Lawrence Riefler.

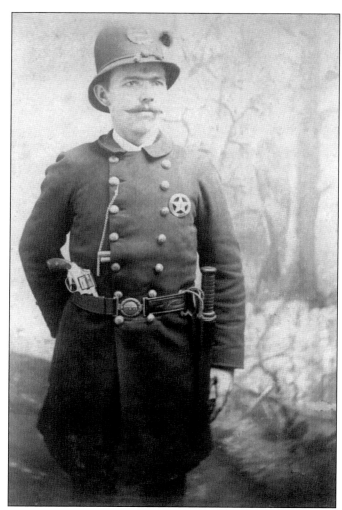

In 1895, Honesdale had its first fully uniformed police officer, John Dailie. The police department is located on Main Street in city hall.

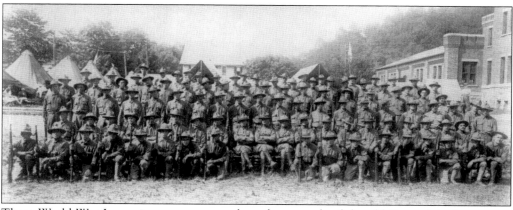

These World War I recruits were encamped on the grounds of the old Honesdale Armory on Park Street. On September 10, 1917, they paraded down Main Street to board a train bound for Scranton to join the rest of their regiment. They shipped out to France on May 3, 1918.

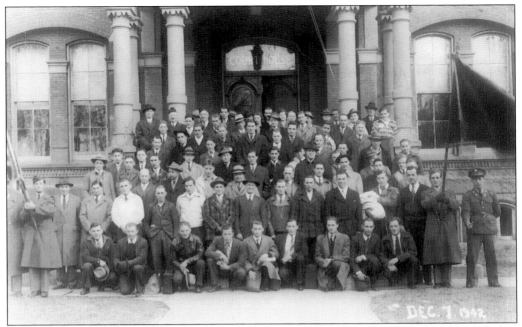

The volunteers pictured here rushed to the courthouse on December 7, 1941, when Pearl Harbor was bombed. Americans made many sacrifices to aid the war effort; children would help by collecting newspapers, tin cans, and even milkweed (to make life jackets).

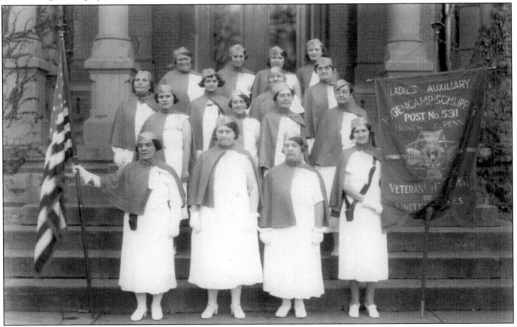

The Ladies Auxiliary of the VFW Milton Hogencamp Post No. 531 poses on the steps of the Wayne County Courthouse. Hogencamp was a local veteran who lost his arm in the war. The Ladies Auxiliary would raise money to help bring soldiers back home and make bandages and other things the soldiers needed.

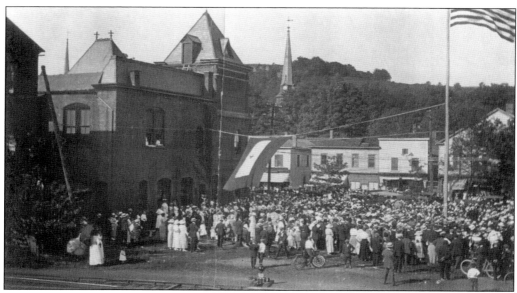

This large crowd gathered next to city hall on July 4, 1918, to celebrate Independence Day. The tall steeple in the background is on the Presbyterian church. During World War II, members of the Civil Air Patrol would sit on top of city hall's roof to watch and listen for planes, tracking them to make sure they did not belong to the enemy.

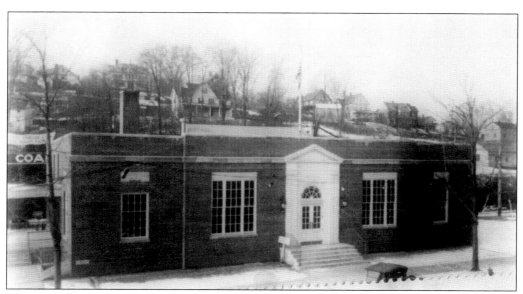

The post office was moved from city hall to this new, larger, and more efficient building erected on Main Street in 1935. The lobby of the post office still contains large murals that depict the canal days in town.

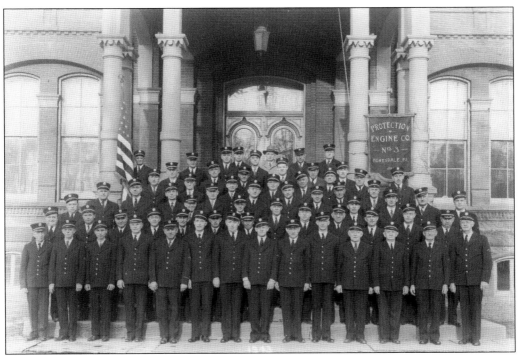

Members of the Honesdale Volunteer Fire Company's Protection Engine Company No. 3 pose for a photographer on the courthouse steps in 1943 in honor of the company's 90th anniversary. Company No. 3 is currently located on the corner of Main and Park Streets, where the fire museum and the only operating Silsby apparatus are located.

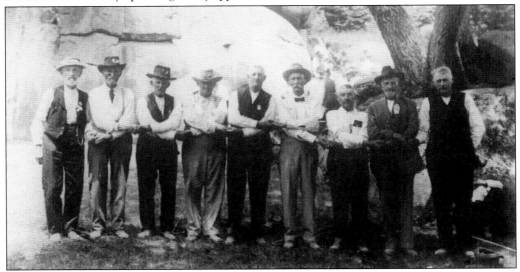

Nine Civil War veterans pose at the Gettysburg reunion in 1913. They are, from left to right, Thomas Bates, from Clinton Township, Pennsylvania; R.R. Tibbett, from Clifton Ford, Virginia; Samuel Found, from Prompton, Pennsylvania; D.M. Reynolds, from Clifton Ford; Joel Hill, from Lookout, Pennsylvania; Henry Humphry, from Virginia; J.E. Cook, from Honesdale; J.W. Thomas, from North Carolina; and Daniel Kimble, from Dyberry Township, Pennsylvania.

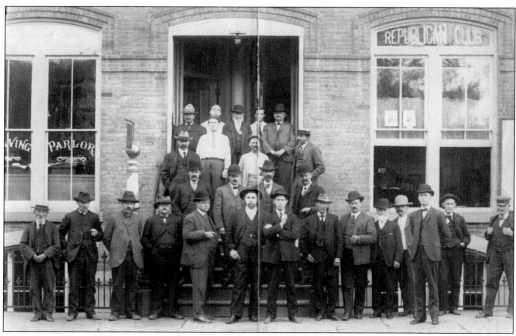

Members of the Republican Club stand on the steps of the Allen House. The lettering on the windows reads "Shaving Parlor" and "Republican Club." The Republican Club held meetings at the Allen Hotel until it burned down in 1978.

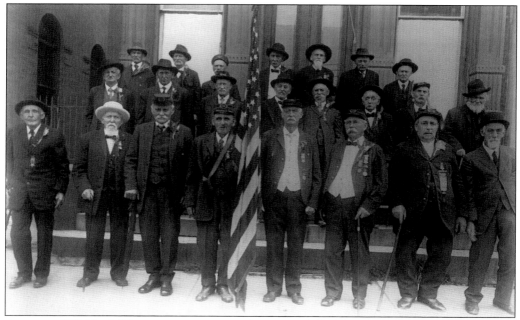

A group of 23 Civil War veterans poses on the steps of the Wayne County Courthouse after marching in a 1918 or 1919 Memorial Day Parade. Posing with a flag, the men are wearing their battle ribbons and medals on their suits. Many are also wearing their military uniform caps.

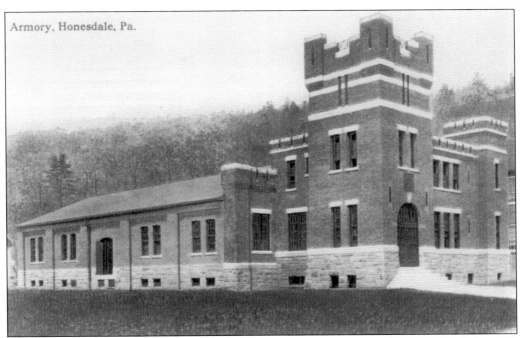

Armory, Honesdale, Pa.

Before World War I, Company E needed a permanent location or it would have to be disbanded. In 1911, a redbrick building was erected on Park Street as the first Pennsylvania State Armory. The construction of the building cost $23,000; at the time, the building was the property of the state, but Honesdale was its custodian. In 1986, the state sold the property to the YMCA; a new armory, which cost $7 million, had been built on Tryon Street in 1977.

This c. 1920 view of Central Park shows the two Parrott 100-pounder cannons (from the Civil War) and the Civil War Monument. The bases of these cannons are currently located in front of the Old Stone Jail; the cannons themselves were donated to the war effort during World War II.

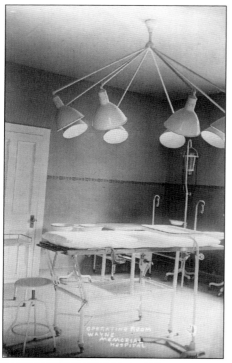

This is the operating room in the first Wayne Memorial Hospital. Originally, doctors would make house calls to visit sick people, but in 1893, a group of prominent people came together to look into having a separate building for the sick. However, it was not until 1919 that the Wayne Memorial Hospital Association purchased the 22-room Dimmick home for $10,000. The hospital was named in honor of the 55 local soldiers who died during World War I.

The 1942 flood washed away the bridge between Fourth Street and Willow Avenue. The tall building in the center, which was a glass factory and then a shoe factory, is located at the bottom of Cliff Street.

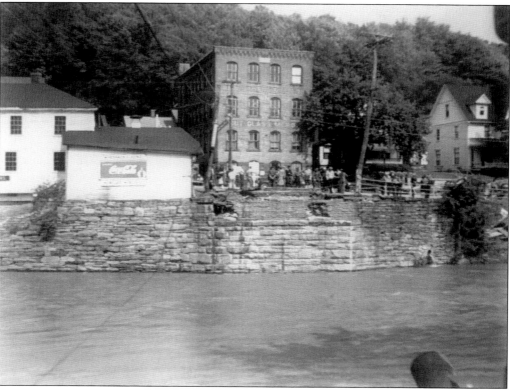

Six

FLOODS, ICE, AND SNOW DISASTERS

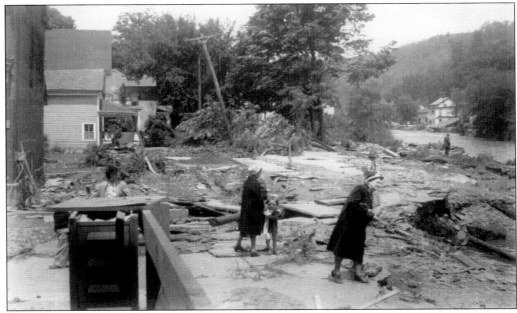

So many people lost everything they had after the 1942 flood. Many families tried to move things to the second floor if possible, and people would swim across rooms to save family heirlooms. With bridges washed out, there was no communication or way for people to get home. Families who lived on higher ground would open their home to others. The smell of mud was everywhere.

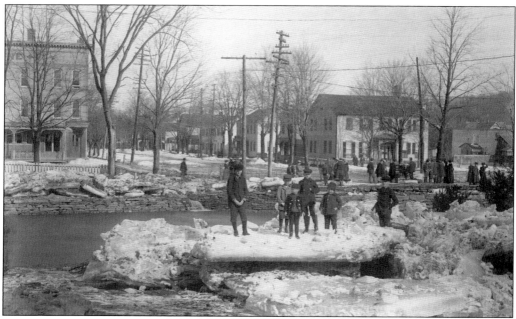

After a week of snow accumulating to 30 inches, followed by 24 hours of rain, Park Lake, on the Lackawaxen River was completely covered with ice. An attempt was made to dynamite it in an effort to save the bridge on Main Street, however, the ice would not break, and the bridge was swept away. On Friday, February 28, 1902, the river overflowed its banks. Floodwater and huge chunks of ice swept through Honesdale. During the following days, men and boys worked to clear the ice from the streets. In the above photograph, the river is flowing freely, and in the photograph below, one man is holding a chunk of ice with ice tongs while others survey the situation.

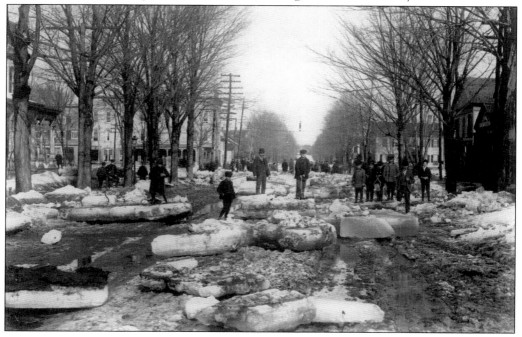

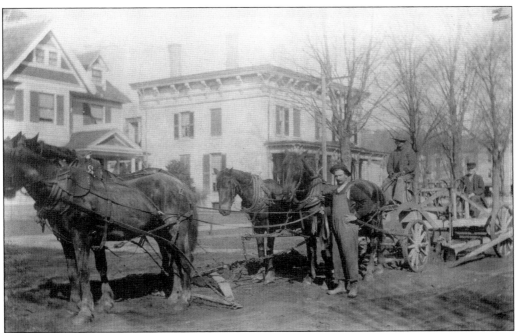

This street crew is cleaning mud from Main Street after a flood. Today, one man operating a machine could clear the street, but it took at least three men to work this apparatus.

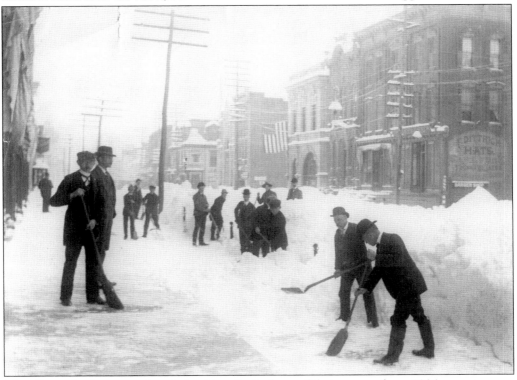

Main Street businessmen shovel the sidewalks in front of their stores after a 1906 snowstorm.

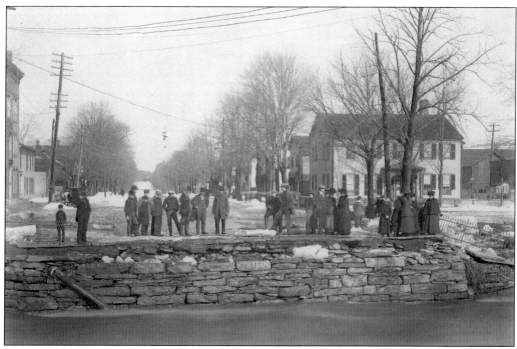

During the 1902 ice flood, the Main Street bridge was washed away, and residents on the north side of the bridge had to take a very long detour to get downtown for food and supplies. The two-story home in the background, which has since been torn down, was said to have been part of the Underground Railroad.

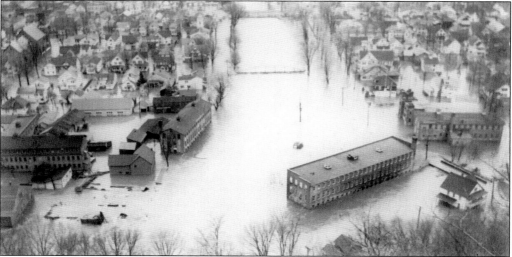

This aerial photograph, taken from Irving Cliff, shows what appears to be a fenced area in the middle of the Lackawaxen River during the 1936 flood. The top of the "fenced area" is the Main Street bridge, and the bottom is the footbridge that crosses the river at Court Street. The sides are the trees that are line each river bank. The large rectangular building at lower right is the Honesdale Union Stamp and Shoe Company (HUSSCO), and the Pennsylvania State Armory is to its right.

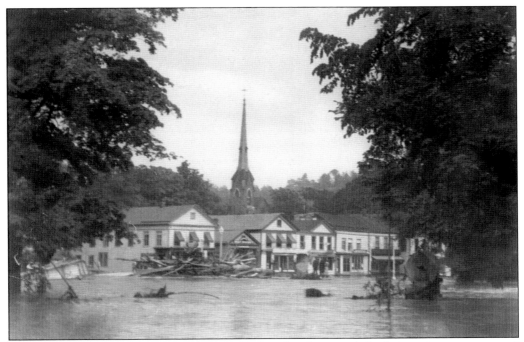

In the May 1942 flood, 13 Honesdale residents lost their lives, and the devastating waters caused overwhelming destruction. This view of the flooded Lackawaxen River shows water rushing onto Main Street at the point where the bridge had been washed away. The large pile of debris in the center is in front of Peil's Drug Store at the corner of Twelfth and Main Streets. At lower right, under the tree, is the Revolutionary War monument erected by the Daughters of the American Revolution, which still stands on the Park Street riverbank.

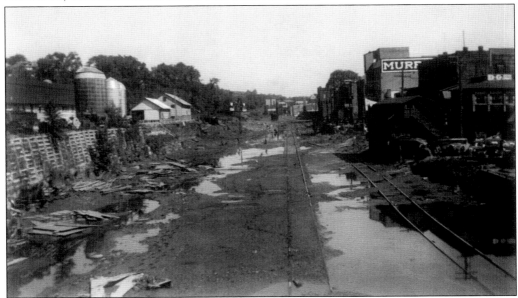

This 1942 photograph shows debris and rubble along the railroad tracks in the area that was formerly the D&H Canal. The Murray Company's warehouse is at left (with the silo).

The Katz Underwear Company is shown here after the May 1942 flood along with all the debris on Sixth Street. The flood caused a lot of damage to many businesses in town, and many stores had "flood sales" to get whatever money they could for ruined items. After the flood, residents could walk down Main Street and see clothes and shoes covered in mud in front of the stores.

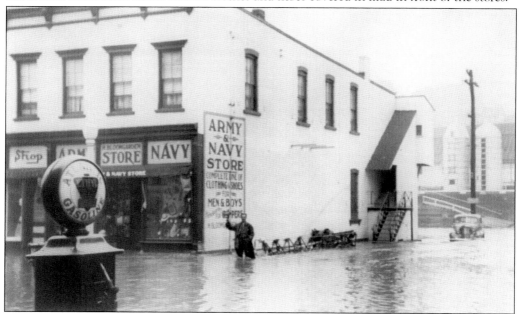

The night of the May 1942 flood was also the night of the Honesdale High School prom. When the flood conditions were announced, some students stayed to assist with moving furniture and equipment to the second floor. Male students with dates were instructed to immediately leave the building and return the girls to their homes. Many did not heed the warning and were caught in the flood. In this photograph, a man standing in floodwaters up to his knees waves to the photographer at the corner of Fifth and Main Streets.

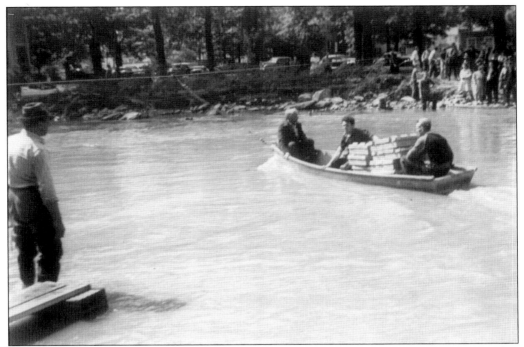

Since the Main Street bridge had washed away due to the May 1942 flood, people and supplies had to be ferried across the swift water in rowboats tethered to a rope that spanned the river. People lined up to wait their turns to use the rowboats to get to work.

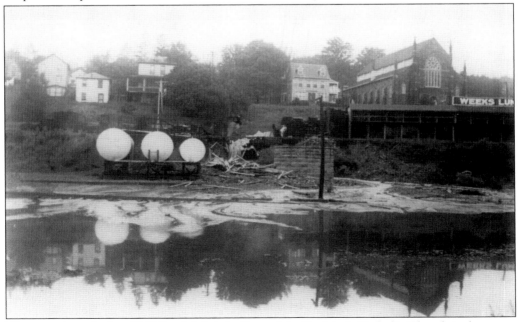

This is a view of other 1942 flood debris in Honesdale. St. John's Catholic Church is shown, as is Weeks Lumber. The train tracks that ran just above the tanks are also visible. These tracks were used for deliveries to Weeks Lumber.

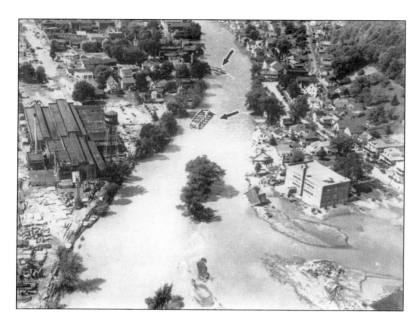

This aerial view of the Lackawaxen River at the lower end of Honesdale shows the Gurney Electric Elevator Company at left and Lincoln Elementary School at right. The arrows in the center of the river are pointing to two of the washed-out bridges.

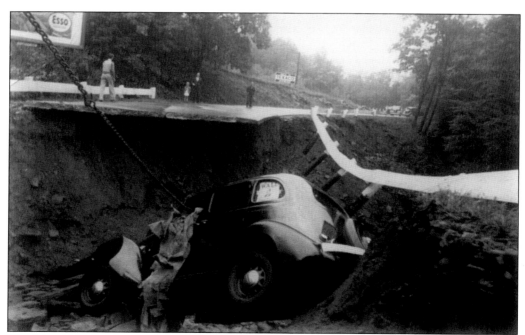

The May 1942 flood caused havoc in town. Homes were washed off their foundations, people floated away on mattresses or became stuck in trees, and roads would open up and swallow a car, as shown here.

An unidentified man tries to figure out how to retrieve his car after the May 1942 flood. Adam Jeko's home, in the background, was knocked off its foundation. The home was later put back on its foundation and still stands on Lincoln Street.

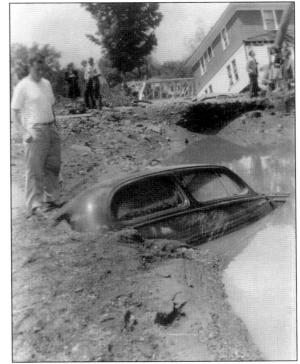

After the May 1942 flood, people placed furniture and equipment on the sidewalk in order to clean the muddy stores. Wet garments from the clothing stores were hung out to dry. The pit in the foreground of this photograph is where a scale used by the City Coal Company was washed out.

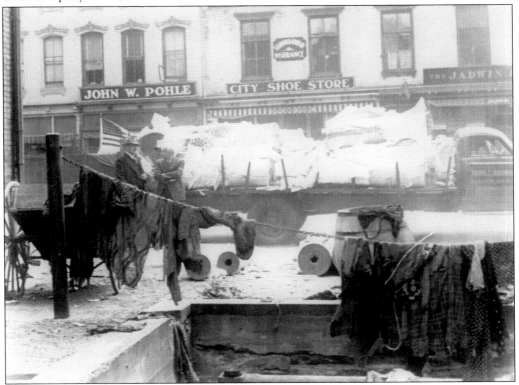

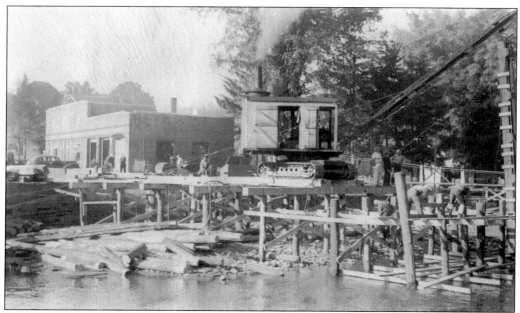

This steam crane is driving pylons into the Lackawaxen riverbed to build the new Main Street bridge after the old one washed away in the May 1942 flood. The Texaco gas station is in the background. A man died while building this bridge when the crane tipped over into the river.

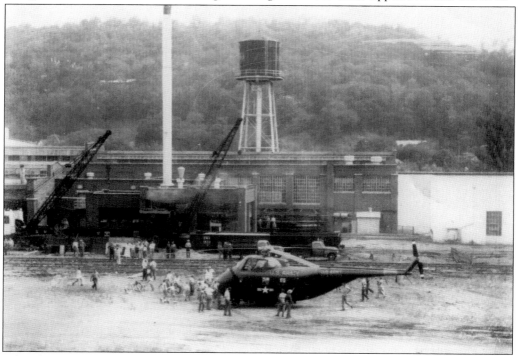

After the August 1955 flood, cranes were brought in to repair the railroad tracks in front of the Lummus Company. The helicopter in the parking lot was used to survey and determine the locations of the damaged areas.

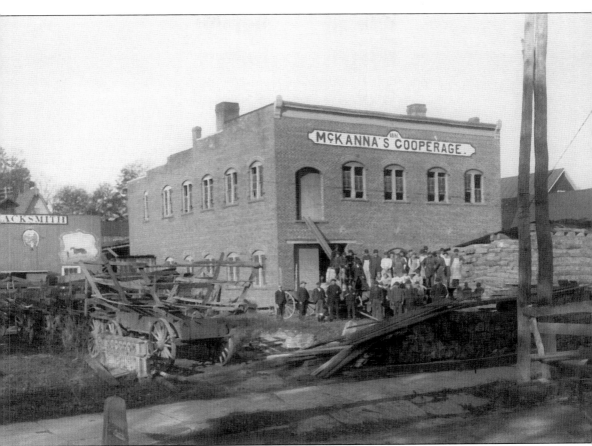

On October 5, 1898, a large fire destroyed the McKanna's Cooperage building, Caufield Memorial Works, Patrick McKanna's home, and buildings belonging to Henry Freund, and the big blaze did much damage to other structures. It was a windy day, and the fire hose kept bursting from the water pressure.

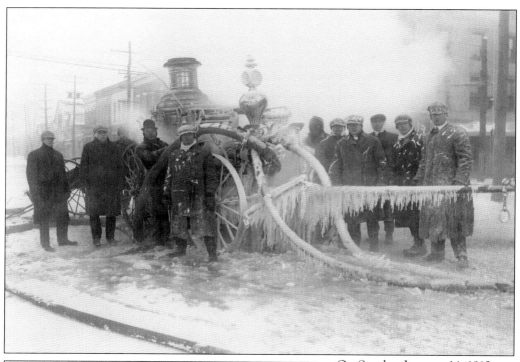

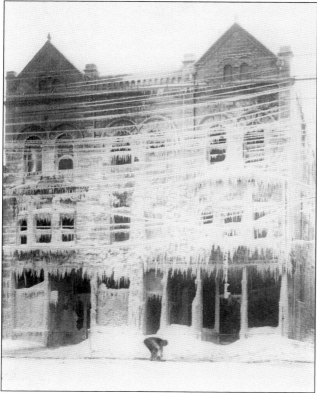

On Sunday, January 14, 1912, the temperature was 25 to 35 degrees below zero at the time of the fire at the Reif-Spettigue building on Main Street. The water froze immediately on the Silsby steam engine (above), and many of the firemen from Protection Engine Company No. 3 endured frostbite and frozen extremities. The left side of the building was occupied by O.M. Spettigue's hardware store, and W.J. Reif's shoe store occupied the right side. After the fire, the body of fireman George Bergmann was found buried in the ruins of the hardware store. At the time of this publication, he is the only Honesdale firefighter ever to perish in a fire.

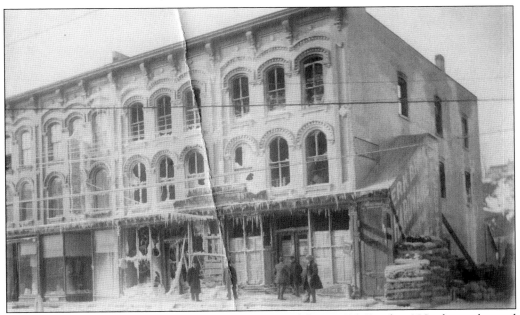

This photograph shows the aftermath of one of several fires at Erk Brothers' Hardware, located at 700–704 Main Street.

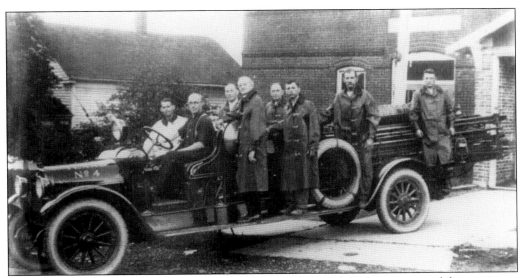

Members of the Texas No. 4 Fire Company are standing on their first motorized fire engine, a 1922 Reo. The driver is Fred Castek. One day, on their way to a fire, the truck was moving too fast over the railroad tracks, so when it hit the tracks, everything fell off the truck. By the time the company got everything back on the truck, the fire was out.

DISCOVER THOUSANDS OF LOCAL HISTORY BOOKS
FEATURING MILLIONS OF VINTAGE IMAGES

Arcadia Publishing, the leading local history publisher in the United States, is committed to making history accessible and meaningful through publishing books that celebrate and preserve the heritage of America's people and places.

Find more books like this at
www.arcadiapublishing.com

Search for your hometown history, your old stomping grounds, and even your favorite sports team.

Consistent with our mission to preserve history on a local level, this book was printed in South Carolina on American-made paper and manufactured entirely in the United States. Products carrying the accredited Forest Stewardship Council (FSC) label are printed on 100 percent FSC-certified paper.

MADE IN THE USA